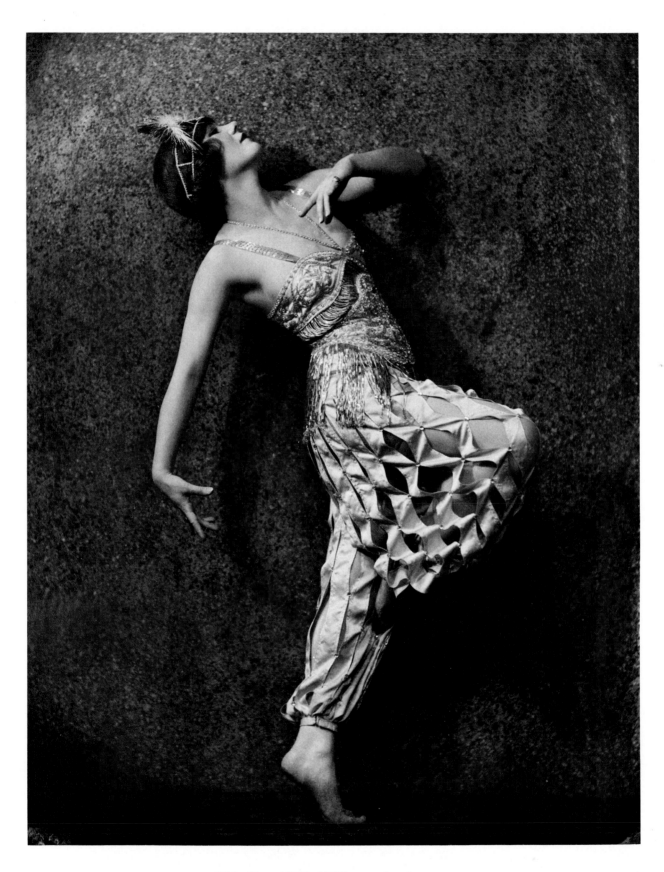

Gilda Gray (1901–1959), popular dancer.

MURAY'S
CELEBRITY PORTRAITS
of the Twenties and Thirties

135 Photographs by Nickolas Muray

Introduction by
Marianne Fulton Margolis

Dover Publications, Inc., New York
and
International Museum of Photography
at George Eastman House, Rochester

Published in Canada by General Publishing Company,
Ltd., 30 Lesmill Road, Don Mills, Toronto, Ontario.
Published in the United Kingdom by Constable and
Company, Ltd., 10 Orange Street, London WC2H 7EG.

Muray's Celebrity Portraits of the Twenties and Thirties is a
new work, first published in 1978 by Dover Publications, Inc.,
in association with the International Museum of Photography
at George Eastman House, Rochester, which made available
for reproduction the original prints in its collection. A new
Introduction has been written specially by Marianne Fulton
Margolis.

International Standard Book Number: 0-486-23578-5
Library of Congress Catalog Card Number: 77-87448

Manufactured in the United States of America
Dover Publications, Inc.
180 Varick Street
New York, N.Y. 10014

INTRODUCTION

Nickolas Muray (1892–1965) came to this country in 1913 a well-educated engraver in the European craftsman tradition. He was born in Szeged, Hungary, and educated in Budapest. At age 12 he entered graphic arts school and learned lithography, photoengraving and the fundamentals of photography. After earning an International Engraver's Certificate he furthered his knowledge by taking a three-year advanced course in color photoengraving in Berlin, where he learned to make color filters. This extended training in color proved valuable because he was able to find work within the first week of landing in New York City. Soon he was employed by Condé Nast, the publisher of *Vogue* and *Harper's Bazar*, as a photoengraver doing color separations and halftone negatives.

By 1920 Muray had opened a portrait studio at his home on MacDougal Street in Greenwich Village. He had been unsuccessful in obtaining work at other photographic portrait studios in New York; one prominent portraitist, Pirie MacDonald, reportedly told Muray that because his portraits broke with tradition he never would get a job as an employee and advised him to open his own studio. Although Muray's work was known by people in the Village, fame did not come overnight, nor were financial difficulties immediately overcome. One possibly apocryphal story which, nonetheless, illustrates the plight of the young portraitist states that when his last 200-watt bulb burnt out he had to close his doors until a check came in from a previous customer. His very working hours, however, testify to his will to become a fine photographer and independent businessman: from ten A.M. until three P.M. he was in his studio, and three hours later he was on the job as a union engraver and worked until two in the morning. It seems incredible that one person could keep up this pace for very long, yet Muray continued filling both jobs for six years!

In 1921, *Harper's Bazar* commissioned him to do a portrait of Florence Reed, who was then starring on Broadway in *The Mirage*. Soon afterwards his pictures filled two pages every month. So at the beginning of the 1920s he was financially stable at last and could leave the engraving job and become an established full-time photographer.

The twenties were a time of tremendous turmoil as the American people tried to come to grips with the changes that were pushing them into a modern age, often against their wishes. The era witnessed unprecedented political scandals, the failure of such reform movements as Prohibition, and the questioning of such traditional values as fundamentalism in the famous Scopes "monkey trial." Muray's sitters included numerous people prominent in this new society: Presidents Coolidge and Hoover, the speakeasy proprietor Barney Gallant, the attorney Clarence Darrow.

Changes were also taking place in the arts and letters, with the "lost generation" of American writers and artists converging in two main centers: Paris and Greenwich Village. In the years when Muray flourished in the Village, it also sheltered Willa Cather, Edna St. Vincent Millay, Ruth St. Denis and Eugene O'Neill, to name just a few. Muray's portraiture reflected the revolution in dance (Fokina, Mordkin, Shawn, Graham), the new approaches to literature (Fitzgerald, Lawrence), the young school of *New Yorker* cartooning (Arno, Covarrubias) and many other artistic trends.

Of course, his work as a whole could not help being influenced by the most publicized twentieth-century trend in the art of photography: the Photo-Secession led by Alfred Stieglitz, which through its widely read quarterly *Camera Work* promoted pictorial photography. This esthetic emphasized the style and design of the print rather than detail, and welcomed handwork on both the negative and

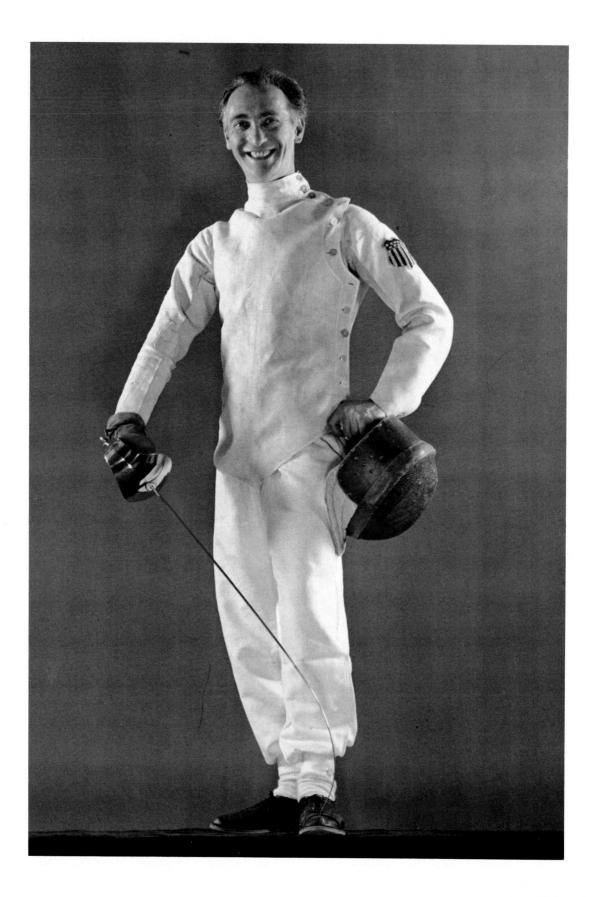

Nickolas Muray, as photographed by Edward Steichen.

the surface of the print. The narrative aspect of pictorialism suited Muray's theater and dance work very well, allowing him to utilize the tone of the drama or music to create a metaphor. The negative was not sacred but could be retouched to obscure distracting detail, thus enhancing the subjects and making them more powerful.

In addition to his portraiture, which will be considered at greater length below, Muray's commercial output included fashion and product work. His scrapbook clippings with examples of his early published photos come from an amazing variety of magazines and newspapers: *Vogue, Woman's Home Companion, Ladies' Home Journal, Vanity Fair, Harper's Bazar, The New York Times, Illustrated Sporting & Dramatic News* (London) and the *New York Telegram,* to name a few. By 1925, Muray Studios had moved to East 50th Street and he was sufficiently well known to be the object of a magazine identification quiz. In its June 13 issue, *The New Yorker* ran an abstract sketch of Muray by the Mexican painter Covarrubias, reminiscent of DeZayas' caricatures in *Camera Work* and Picabia's cartoon of Alfred Stieglitz in *291.* The sketch included a view camera and a spotlight, and the facetious accompanying text invited the reader to identify the person shown.

In 1926, *Vanity Fair* sent Muray on an assignment to London, Paris and Berlin to photograph celebrities. His portraits of George Bernard Shaw, H. G. Wells, John Galsworthy and Claude Monet were taken during this trip. His largest assignment from *Vanity Fair* came in 1929 when he was hired to photograph movie stars in Hollywood. Having signed a four-year contract with *Ladies' Home Journal* in 1930 to do color fashion photography, Muray traveled to Germany to buy the equipment necessary to convert his studio into one of the first color labs in the United States. He had done some commercial color work as early as 1928 and, always a perfectionist, brought back what he thought to be the first one-shot color camera in this country. Thus equipped, he became known as a master of the carbro process.

During these years, in addition to operating the commercial photography studio, he indulged in two other activities which, though at first glance widely divergent, are actually closely interwoven —he wrote reviews for *Dance* magazine about many of the people he had also photographed, and won the National Sabre Championship, 1927. In 1928 and 1932 he represented the United States on the Olympic Team (in 1964 he would be a judge at the Tokyo Olympics). A man who worked with great technical facility in the studio, Muray

transferred this same precision and concentration to the fencing strip; he was a master of the foil, sabre and épée. One can easily imagine an appreciation and love of dance being strengthened by an acute awareness of the strength and health of the body and its controlled movement through space.

Despite the excellence of his other photographic work and outside activities, Muray's chief fame rests on his celebrity portraits. His unpublished notes referring to the twenties indicate that he gave careful thought to this basic aspect of his art:

> Though most of my pictures were made of professionals—I mean professionals in one sense or another—stage, writing or magazine people—explorers, musicians, dancers, painters, sculptors, directors—my job was to put them at ease in a friendly atmosphere. . . . Not only must [the photographer] please the sitter but the sitter's family and also [fulfill] the purpose for which the picture was taken. Much of this knowledge was accumulated by practicing and employing a point of view that will accomplish results—without it it becomes merely copying a person's outward physiognomy without including in the picture the mood, the character, the intelligence, the beauty, the affectionate front which is known to friends, the family . . . publisher, manager, the editor who gives you assignments.

This indicates Muray's pictorial as well as business concerns. He did not catch his sitters off guard and thereby allow the audience to read into the picture an alienation from the world, blandness, or some terrible burden, in the style currently popular. Muray allowed each person to retain an "affectionate front."

In this he not only gave the public something to dream about but he allowed each sitter to create his or her own character. Many are portrayed in individualized "trademark" poses with gestures seemingly all their own. For example, the portrait of Florence Reed shows her reacting to something outside the frame of the picture. It is a detail of her stage character and would be recognized as either a specific part or as representative of a prominent aspect of her typical roles, rather than revealing her personally. The mannerisms tend to date the portrait and obscure Muray's original intention of naturalness.

The gestures of these sitter/characters often seem to be the one unifying aspect shared by both sides of their split personality. Either the attitude reflected a real-life personality and thereby caused the actor to decide to play certain characters, or perhaps the character played and photographed was the one that established the

actor's reputation and came to dominate his personality. One would never confuse the characters created by Lillian Gish with those portrayed by Gloria Swanson.

In her portrait, Lillian Gish is posed as though caught in a moment of reflection. Wearing a girlishly soft and shiny dress, she is completely unassertive, with her head turned toward the side. The seemingly innocent offhand gesture is nonetheless seductive; her arms and hands lead the viewer out from her body and then back to it, her right index finger rests softly on her lips, her long hair is caught up on the back of her head. Her shadow sets her apart from the contrasting dark, rough-textured background and gives a three-dimensional quality to the picture. Perhaps she is not reflecting on anything but merely allowing us to look at her. The photograph seems to represent the Victorian view of the sexuality of innocence.

In contrast, Gloria Swanson fills the picture space. The light background falls away from the darkly dominant figure. The geometric patterns on the clothing help present a modern woman. Her oddly twisted arms lead the viewer back to her face with its sphinx-like expression (the mythological sphinx being part woman, part carnivorous beast). Taken together, Gish and Swanson represent two alternatives of sex appeal promoted by Hollywood in the 1920s and 30s.

Men, too, appear at a variety of distances from the camera (and viewer). Observe, for example, the difference between the brooding, almost too close, picture of Thomas Hart Benton and the removed, subdued and respectful Mr. Hampden. With the exception of the male dancers, however, the men are seldom "acting out" a character. Men such as Coolidge, Darrow and Bartók are seen in frontal direct poses, as opposed to women, who are often captured in more stylized views.

Babe Ruth is pictured holding his Louisville Slugger and wearing his Yankee uniform in a manner strongly reminiscent of daguerrean portraits of the 1840s and 1850s. Just as tradesmen of that era were often pictured with their tools, the prospector with his pan or the butterfly collector with his specimens, Ruth carries the indicators of his identity and station in life. His face shows neither sorrow nor happiness but rather the confident quietness of a man certain of his identity.

In the lighthearted picture of John Murray Anderson and Barney Gallant, Muray has arranged the sitters in a style typical of late nineteenth-century studio portraits. Anderson looks awkwardly prim, with his feet tightly together, his arms close to his body and a corsage-size boutonniere in his lapel. Gallant appears to be more expansive, with a loose grin, one arm around Anderson and the other supporting his snappy bowler. These gestures, appropriate to an 1880s wedding photograph, allow the viewer to participate in the sitters' humor.

The diversity of talent pictured on these pages is truly remarkable. The people portrayed bring nostalgic feelings for earlier times and link with other names to form an unbroken chain to the present. Because we tend to keep the arts, politics and sports in separate categories in our minds, it may come as a shock to realize that Claude Monet, Calvin Coolidge and Babe Ruth lived and were photographed in the same decade, indeed that Ruth hit sixty home runs just one year after Monet died. These people drawn together by Nickolas Muray form a larger portrait of the first part of our century. Muray wrote:

> Photography, fortunately, to me has not only been a profession but also a contact between people—to understand human nature and record, if possible, the best in each individual.

MARIANNE FULTON MARGOLIS

I wish to thank Ms. Michael Brooke Muray, Richard Margolis and W. Paul Rayner for their help with this Introduction.

M. F. M.

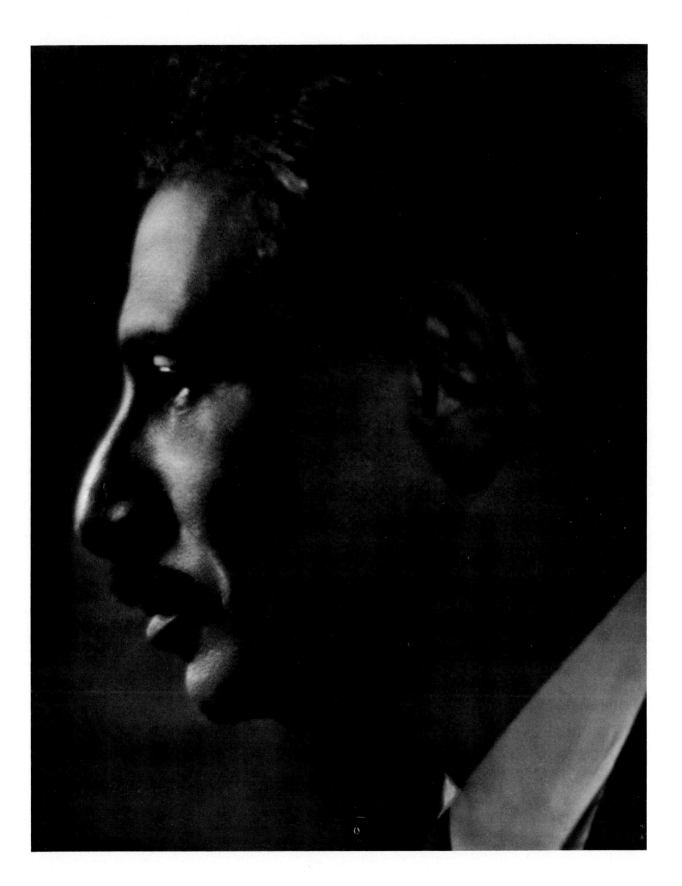

1 F. P. A. (Franklin Pierce Adams, 1881–1960), columnist, humorist.

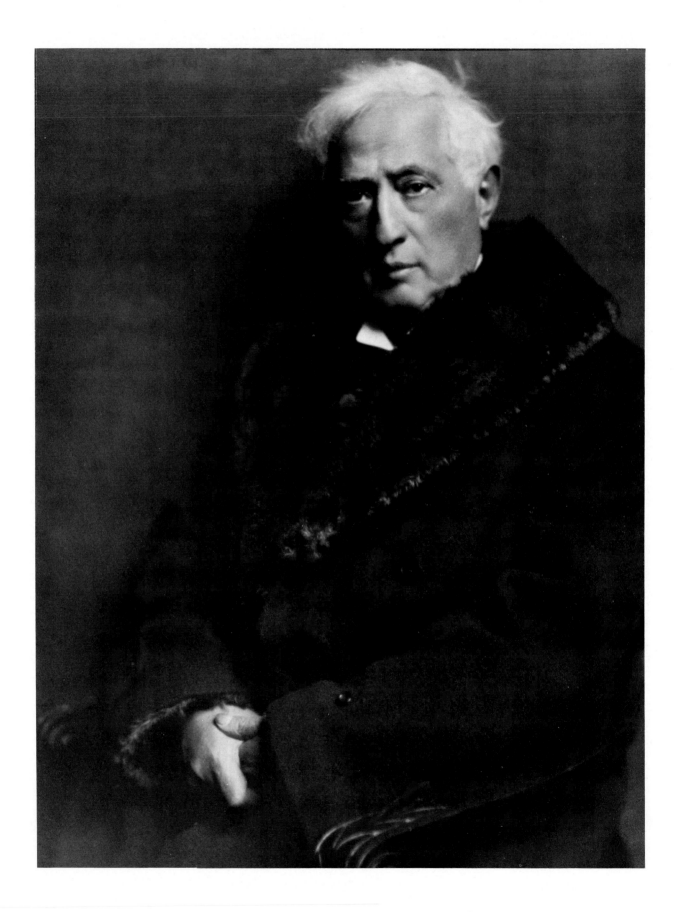

2 Jacob Adler (1885–1926), Yiddish actor.

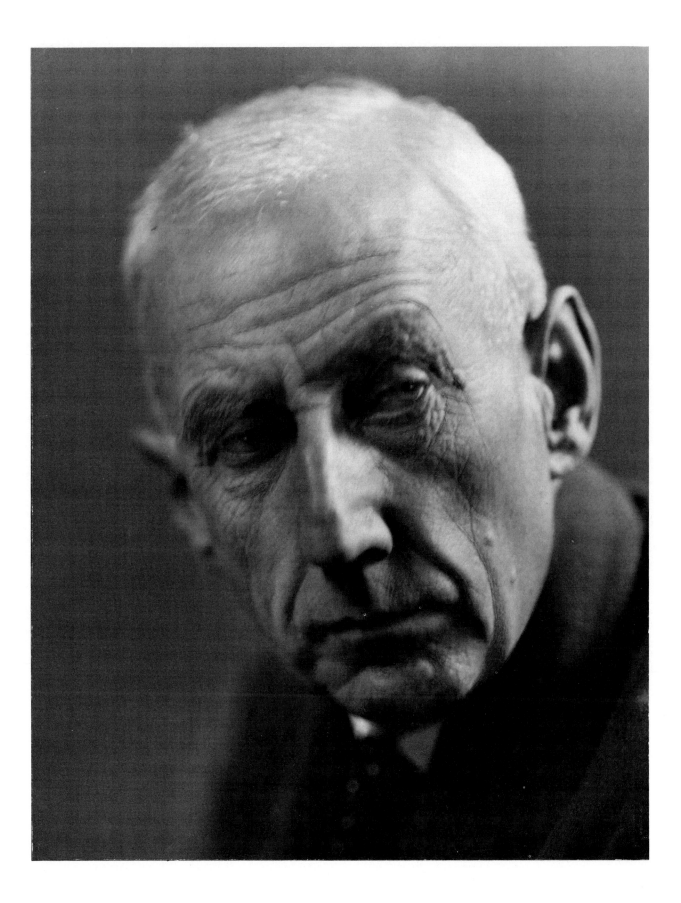

3 Roald Amundsen (1872–1928), polar explorer.

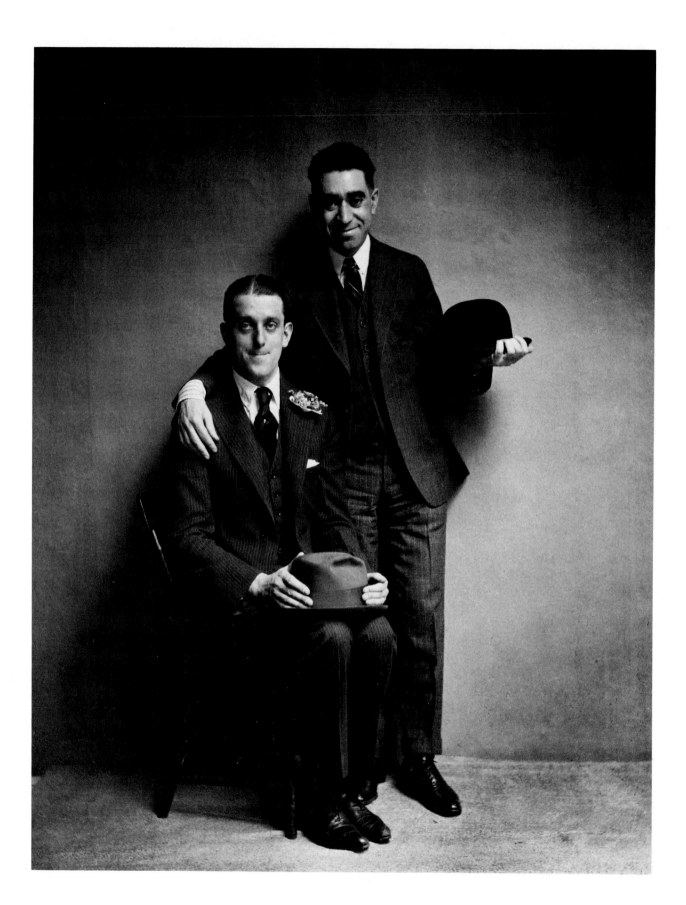

4 LEFT: John Murray Anderson (1886–1954), show producer.
RIGHT: Barney Gallant (died ca. 1949), restaurateur.

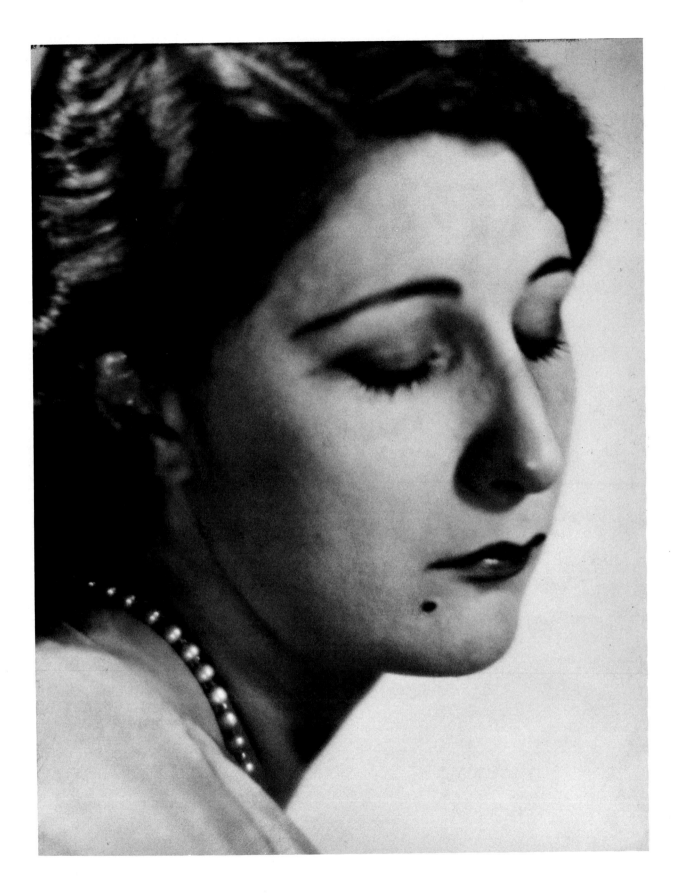

5 Judith Anderson (born 1898), actress.

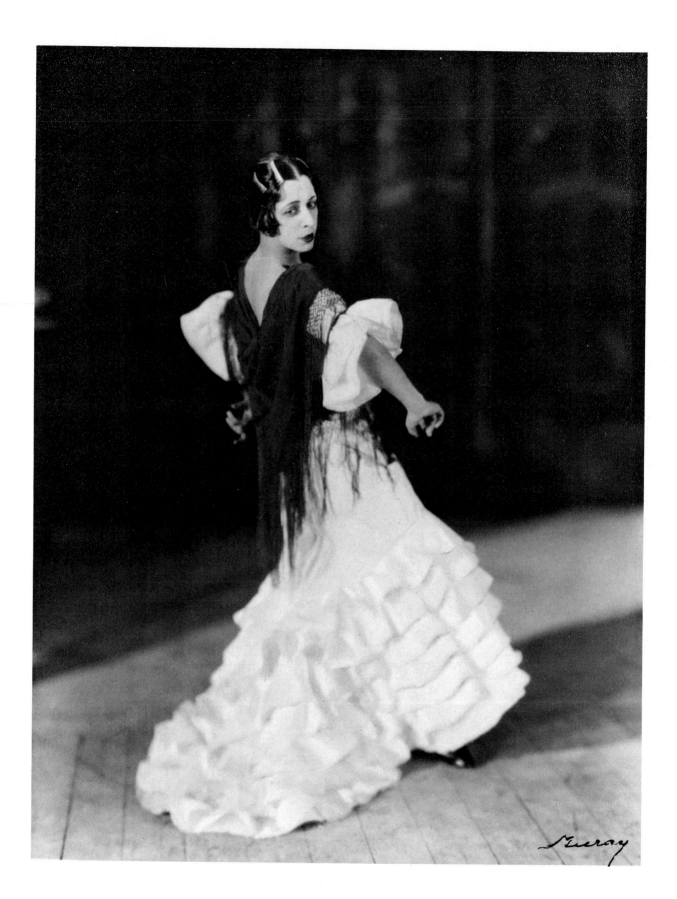

6 La Argentina (Antonia Mercé, ca. 1890–1936), Spanish-style dancer.

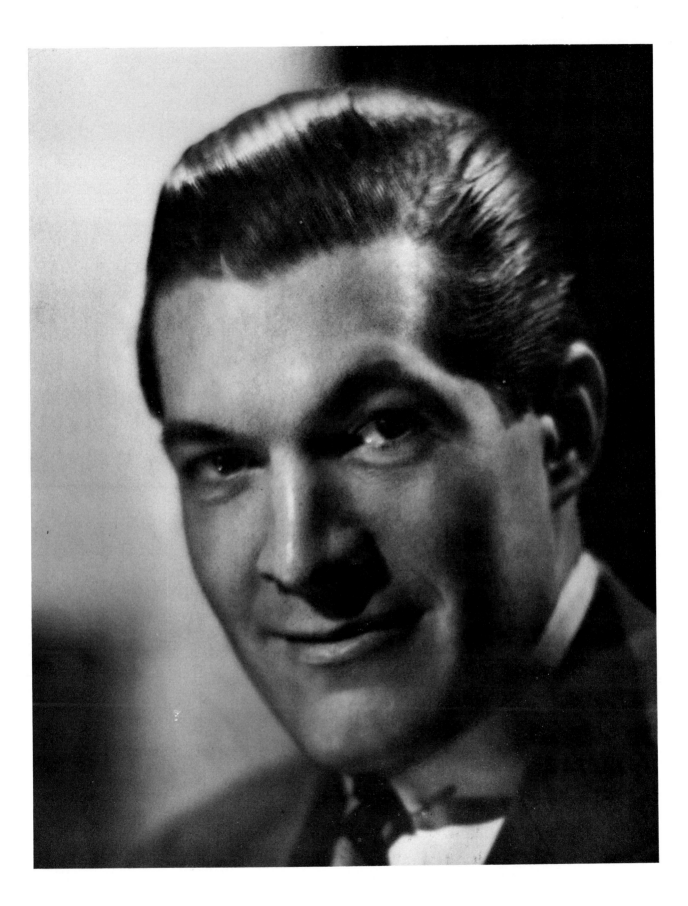

7 Peter Arno (1904–1968), cartoonist.

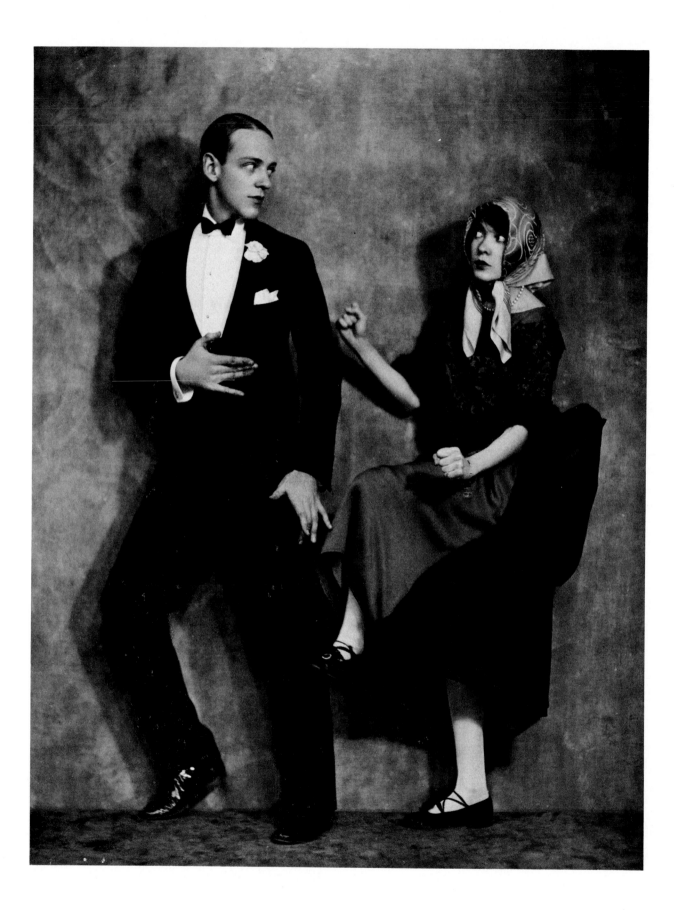

8 Fred Astaire (born 1899) and Adele Astaire (born 1898), popular dancers.

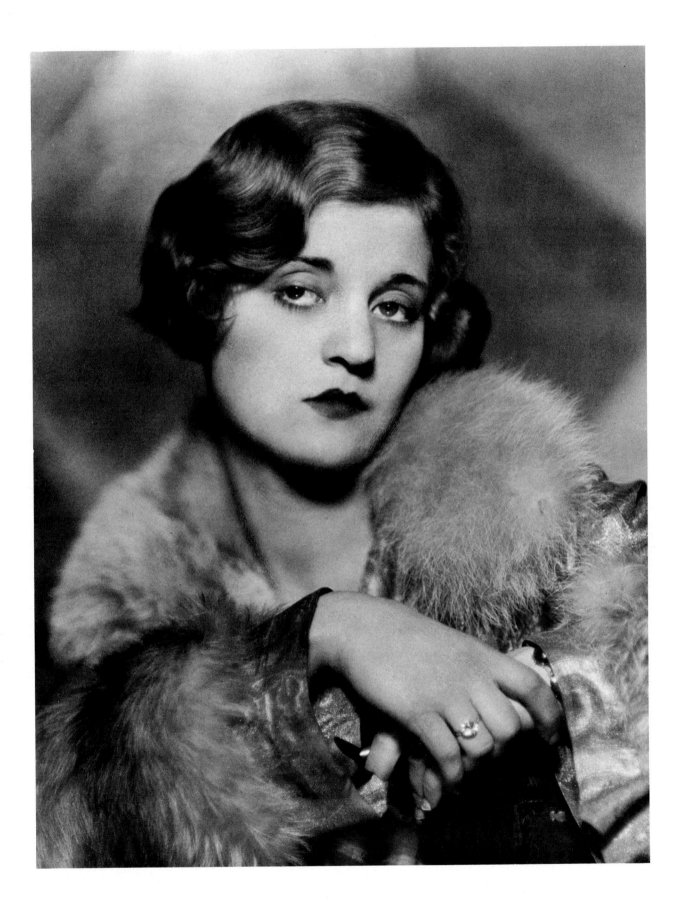

9 Tallulah Bankhead (1902–1968), actress.

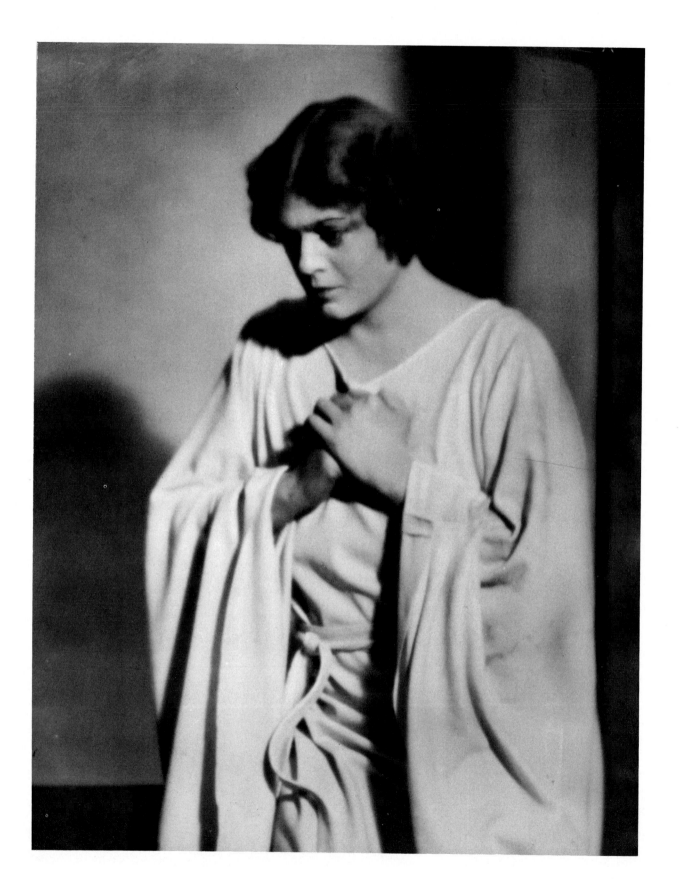

10 Ethel Barrymore (1879–1959), actress.

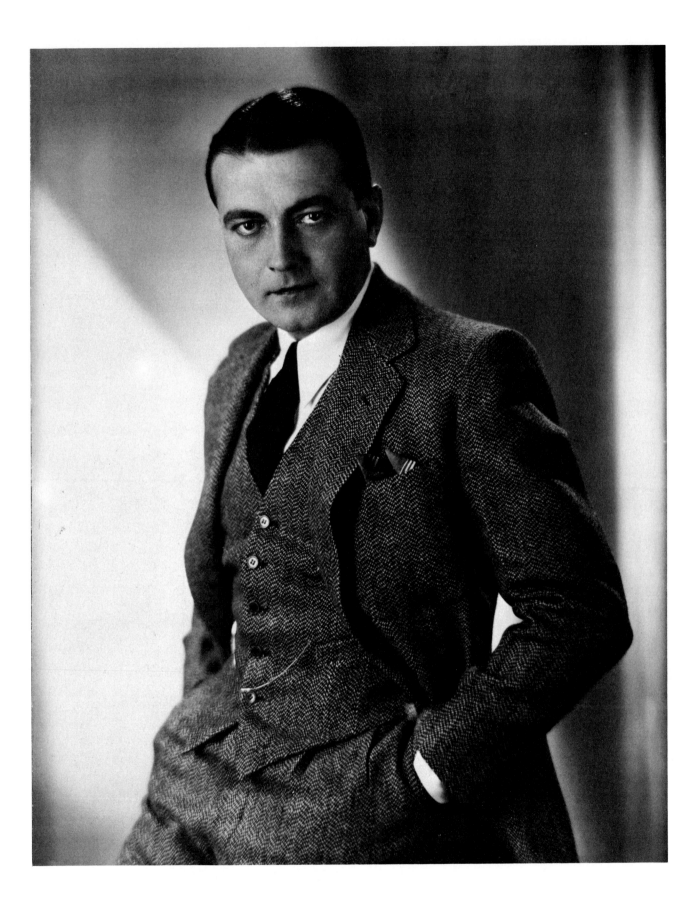

11 Richard Barthelmess (1897–1963), film actor.

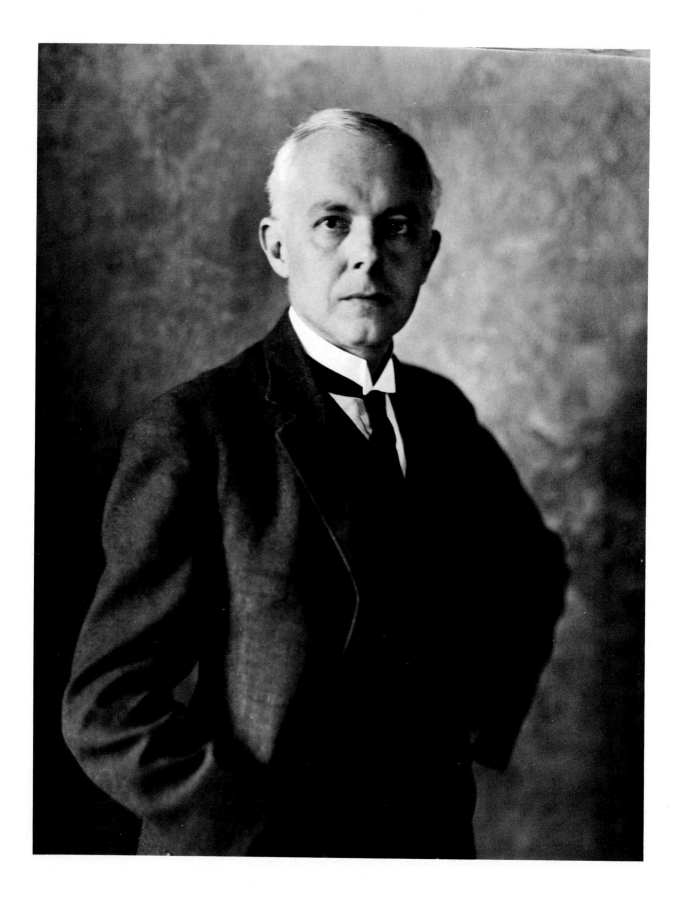

12 Béla Bartók (1881–1945), composer, musicologist, pianist.

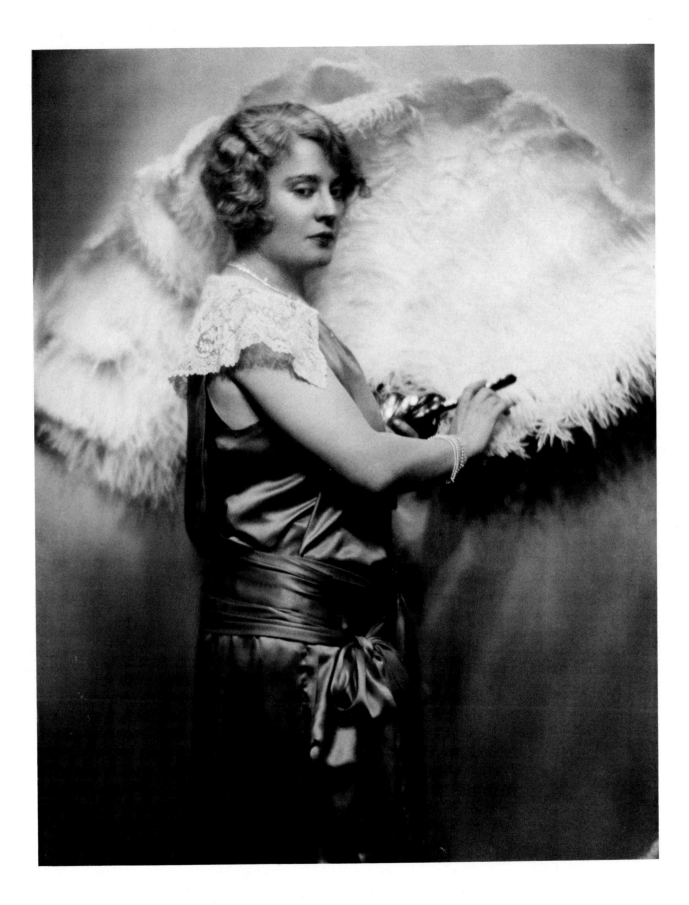

13 Nora Bayes (1880–1928), popular singer.

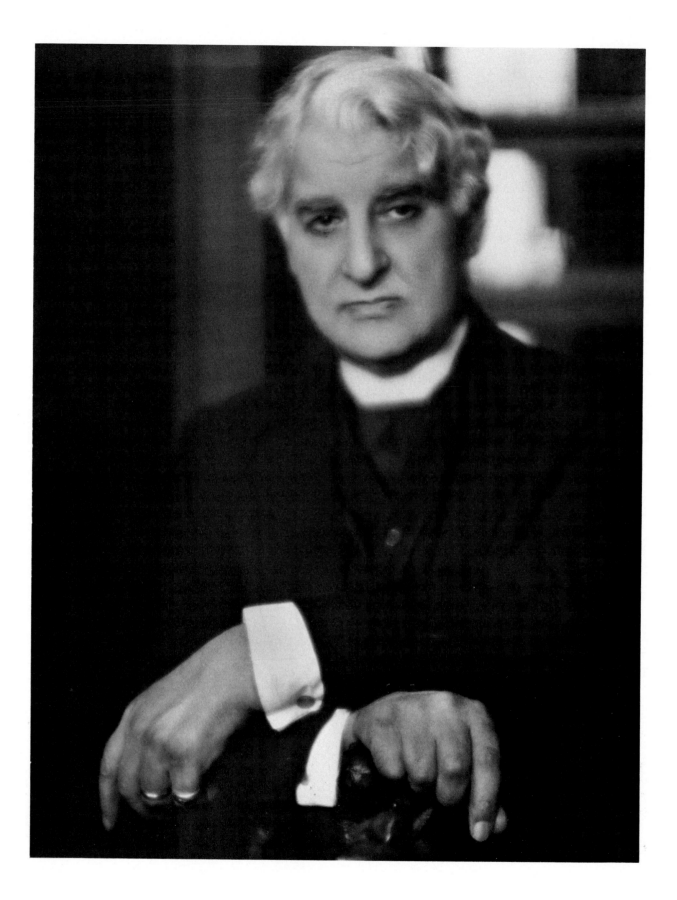

14 David Belasco (1854–1931), playwright, producer.

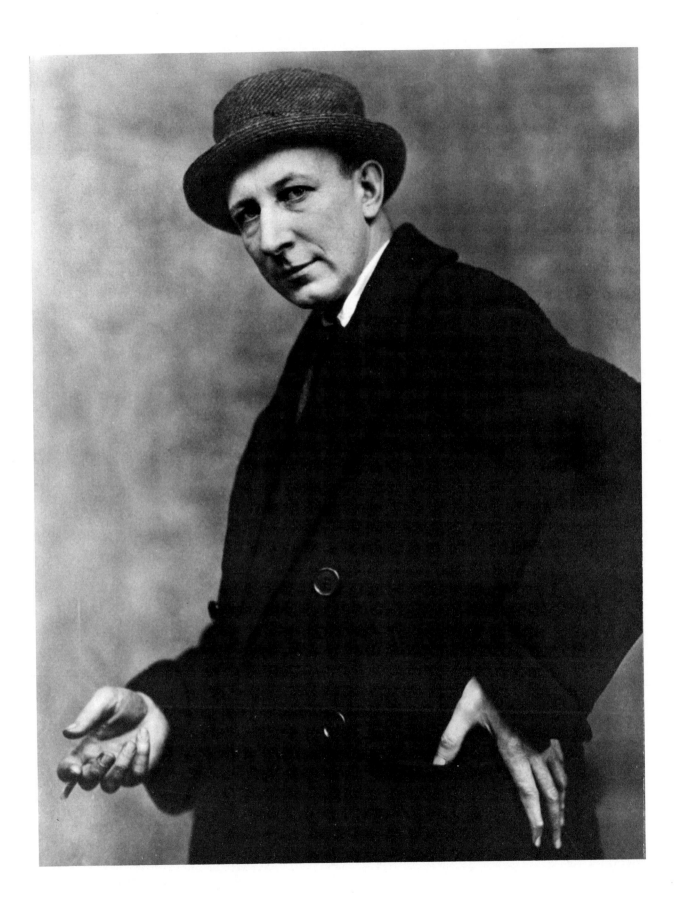

15 George Bellows (1882–1925), artist.

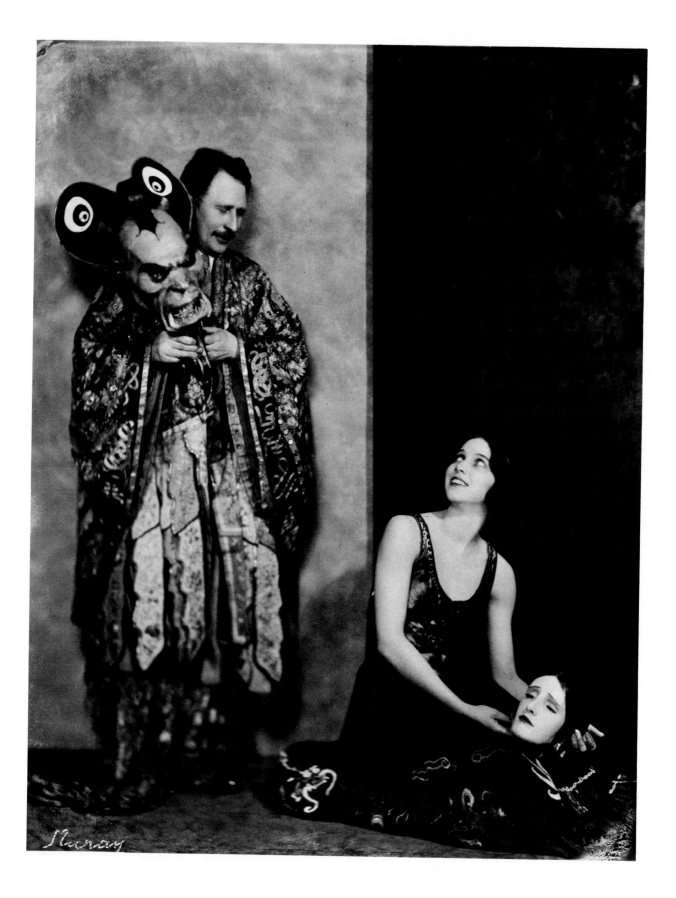

16 LEFT: Wladyslaw Theodor Benda (1873–1948), artist.
RIGHT: Margaret Severn (born 1901), interpretive dancer.

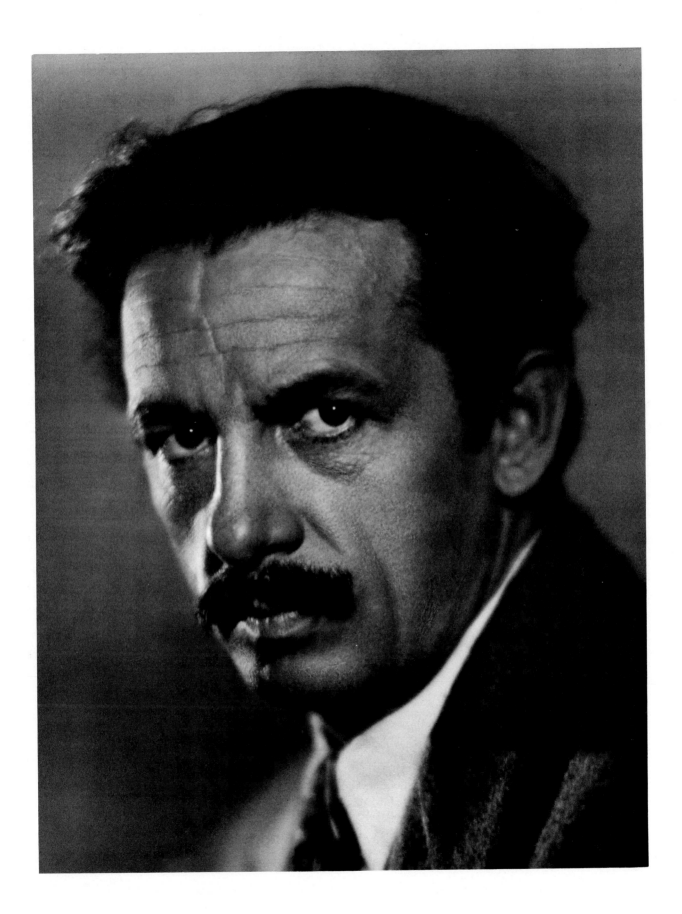

17 Thomas Hart Benton (1889–1975), artist.

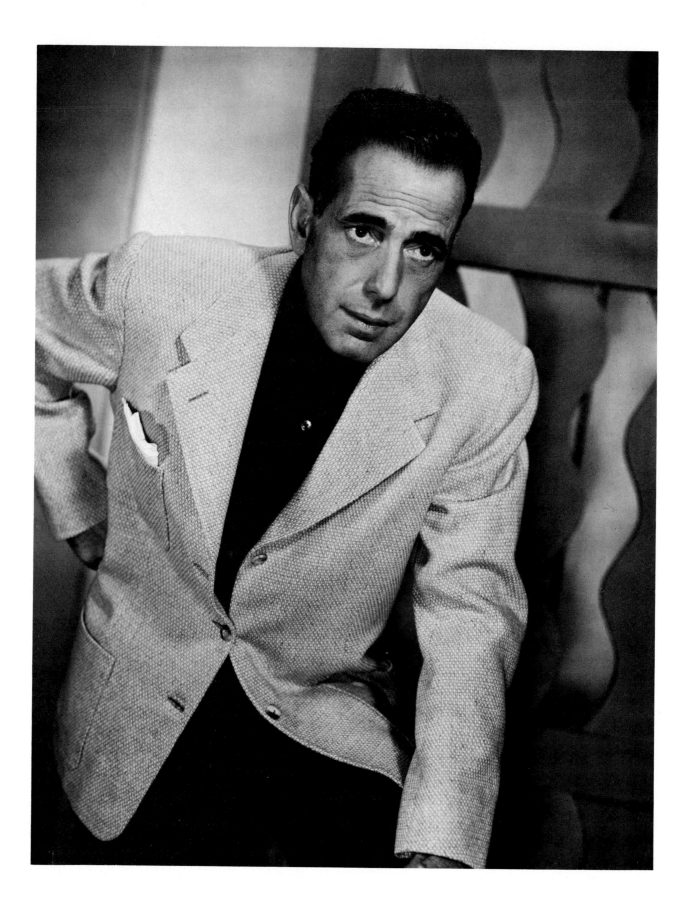

18 Humphrey Bogart (1899–1957), actor.

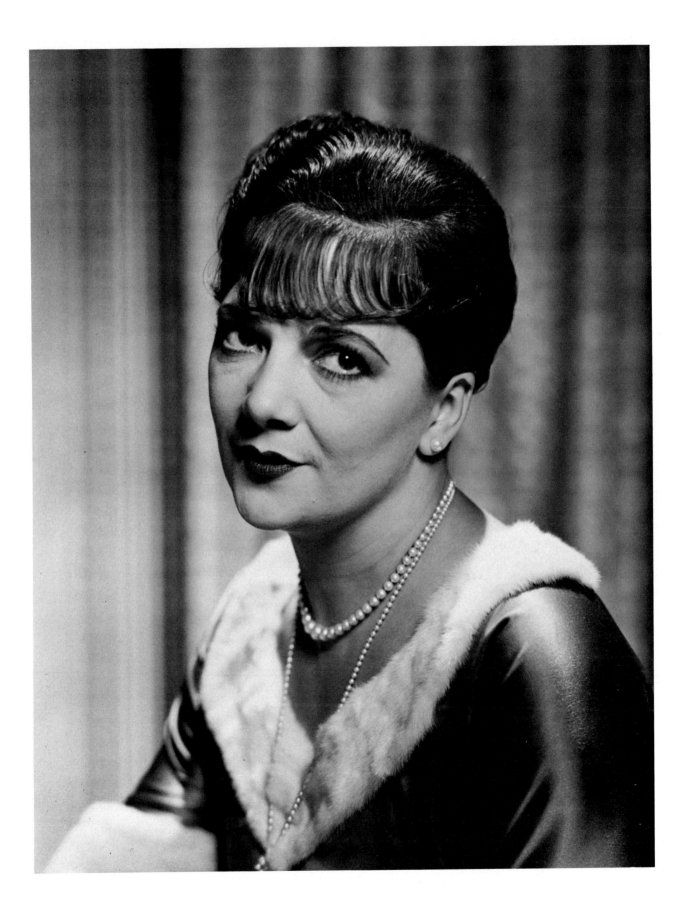

19 Irene Bordoni (1895–1953), popular singer, actress.

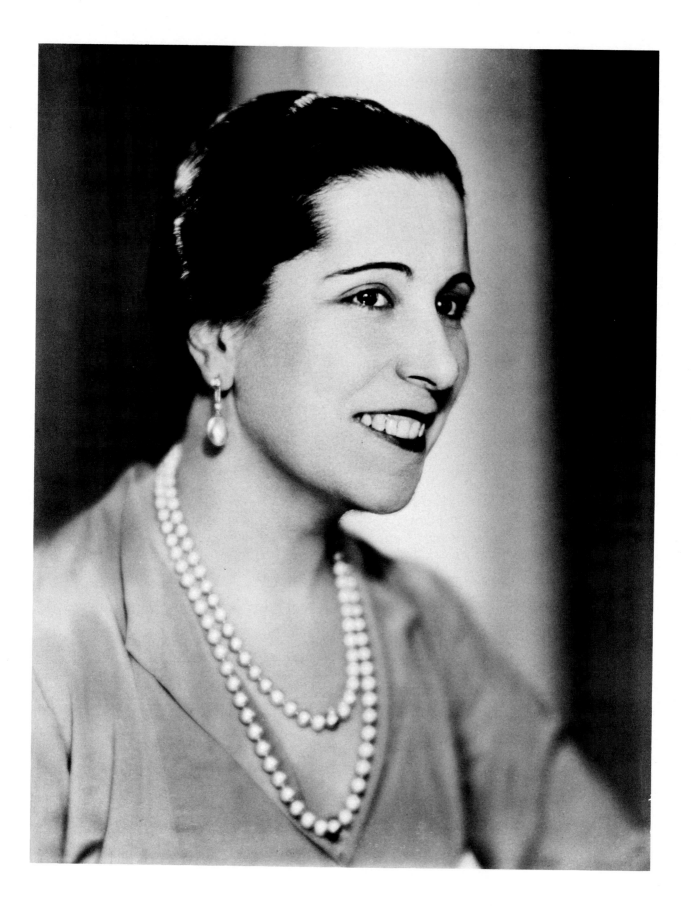

20 Lucrezia Bori (1887–1960), operatic soprano.

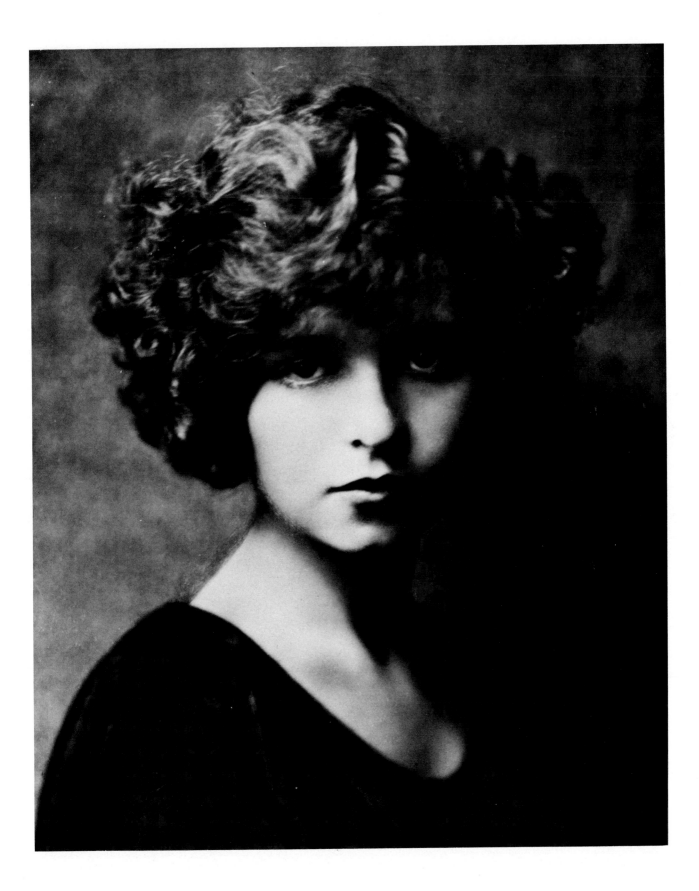

21 Clara Bow (1905–1965), film actress.

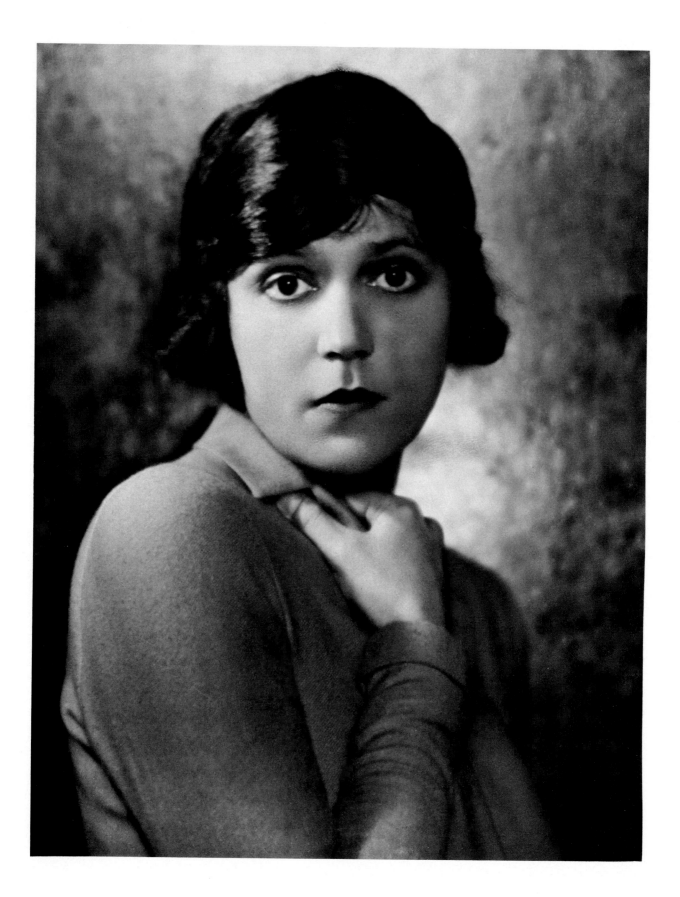

22 Alice Brady (1892–1939), actress.

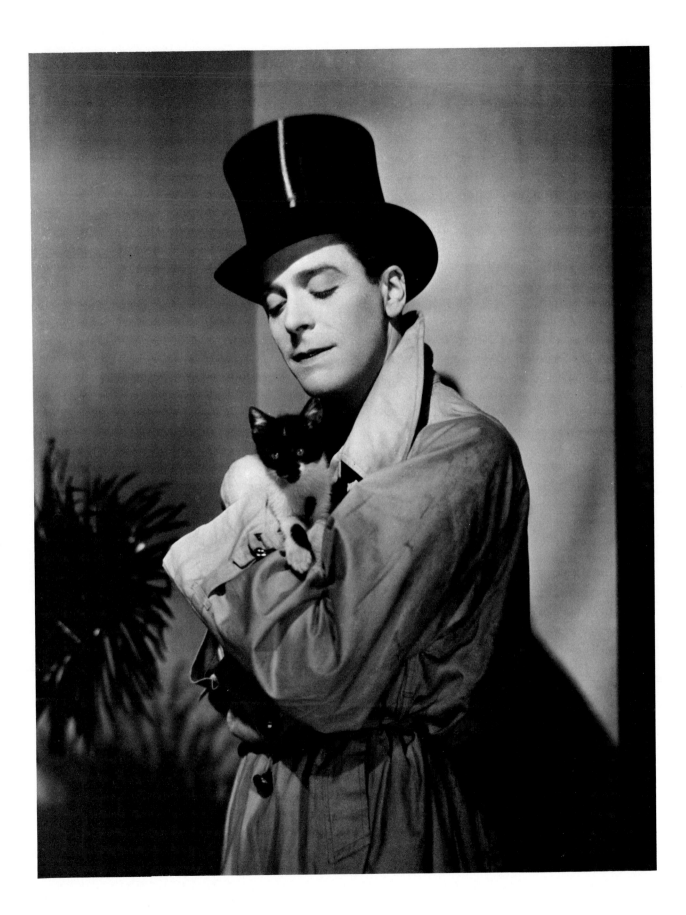

23 Jack Buchanan (1891–1957), popular singer, actor.

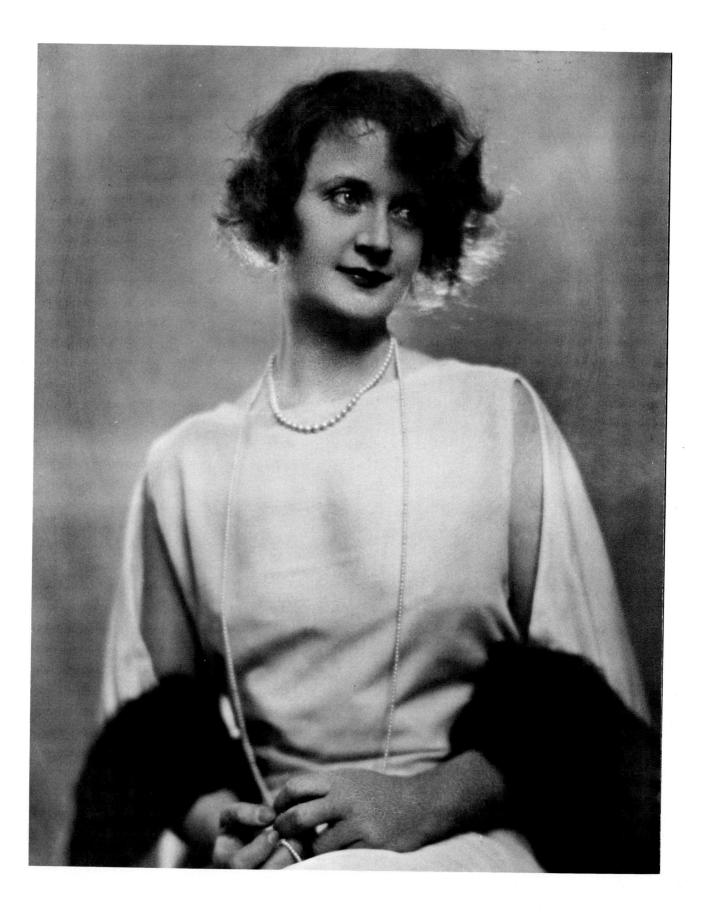

24 Billie Burke (1885–1970), actress.

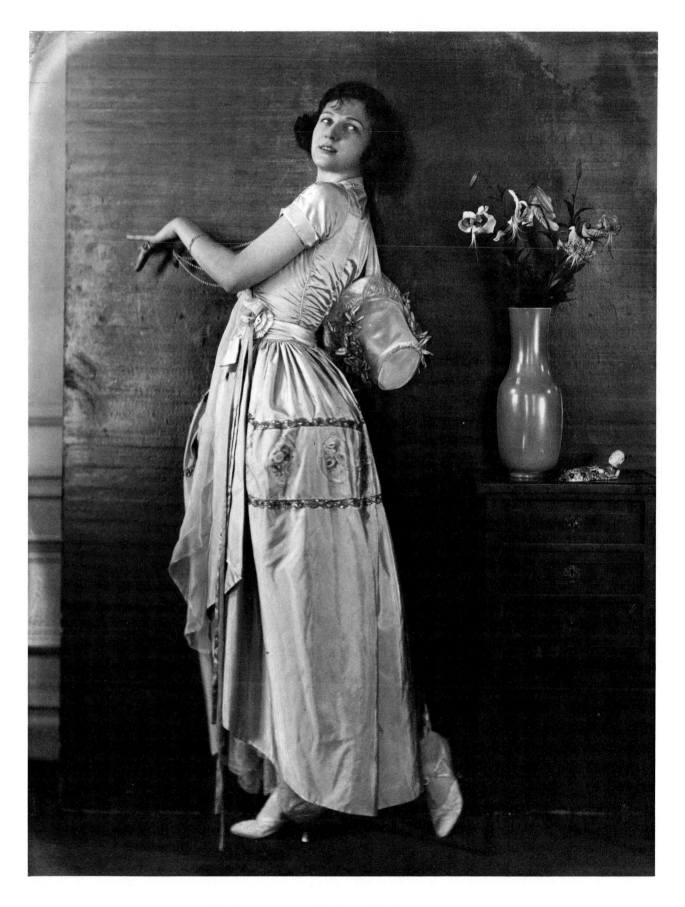

25 Irene Castle (1893–1969), dancer, actress.

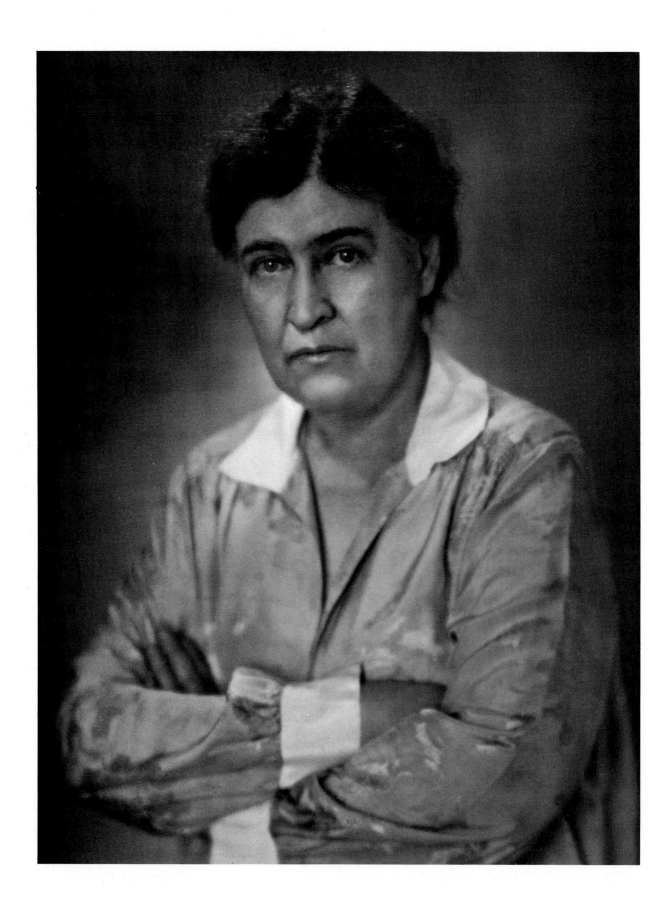

26　Willa Cather (1876–1947), novelist.

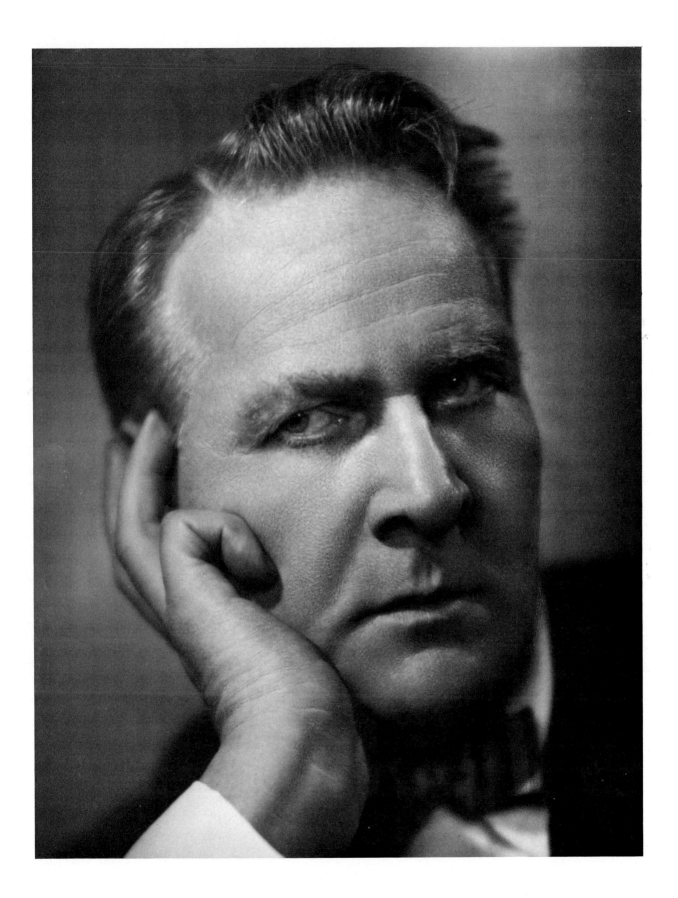

27 Feodor Chaliapin (1873–1938), operatic bass.

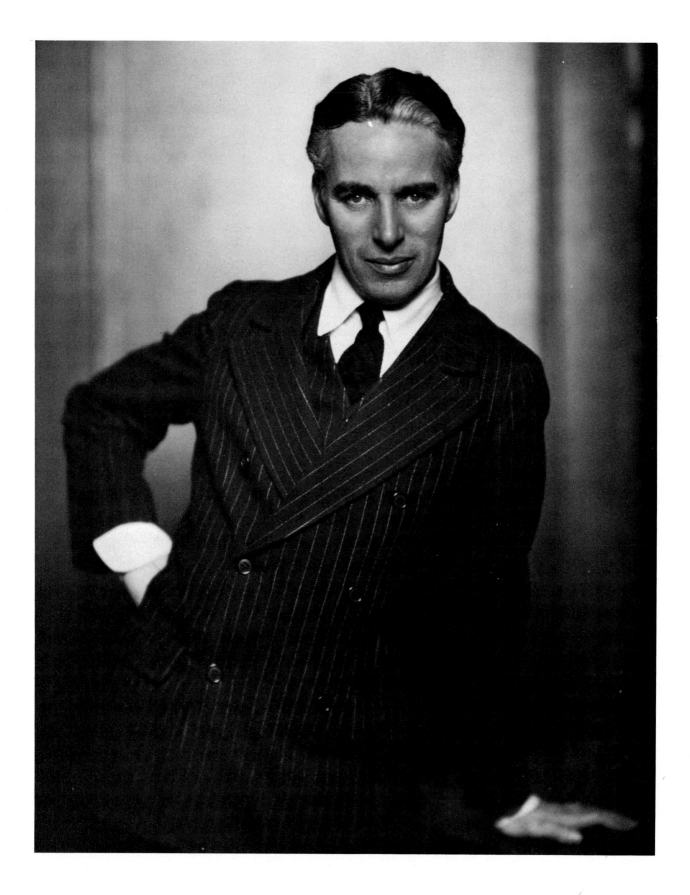

28 Charles Chaplin (1889–1977), comedian, filmmaker.

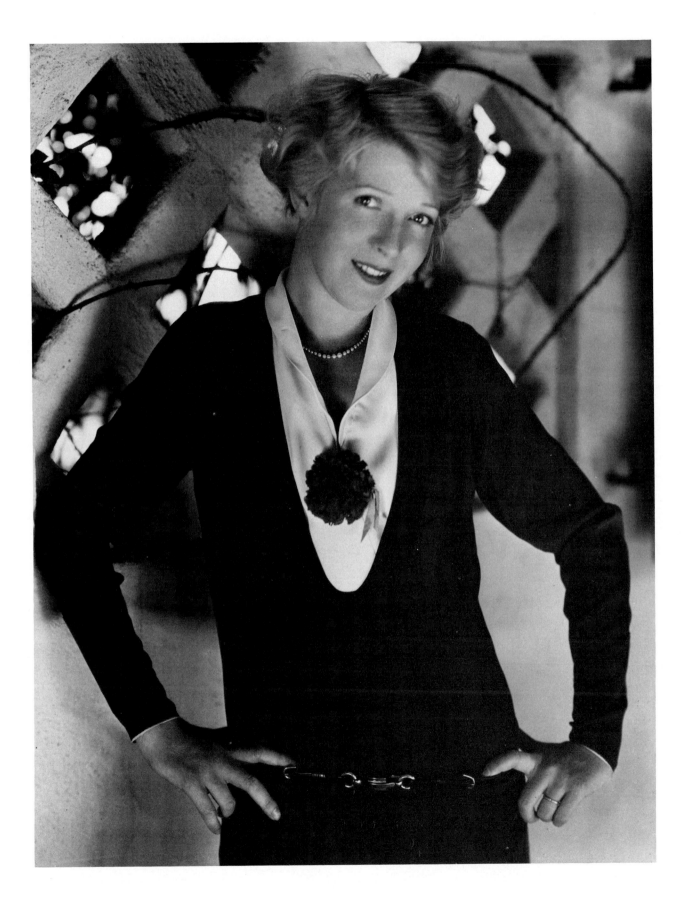

29 Ina Claire (born 1892), actress.

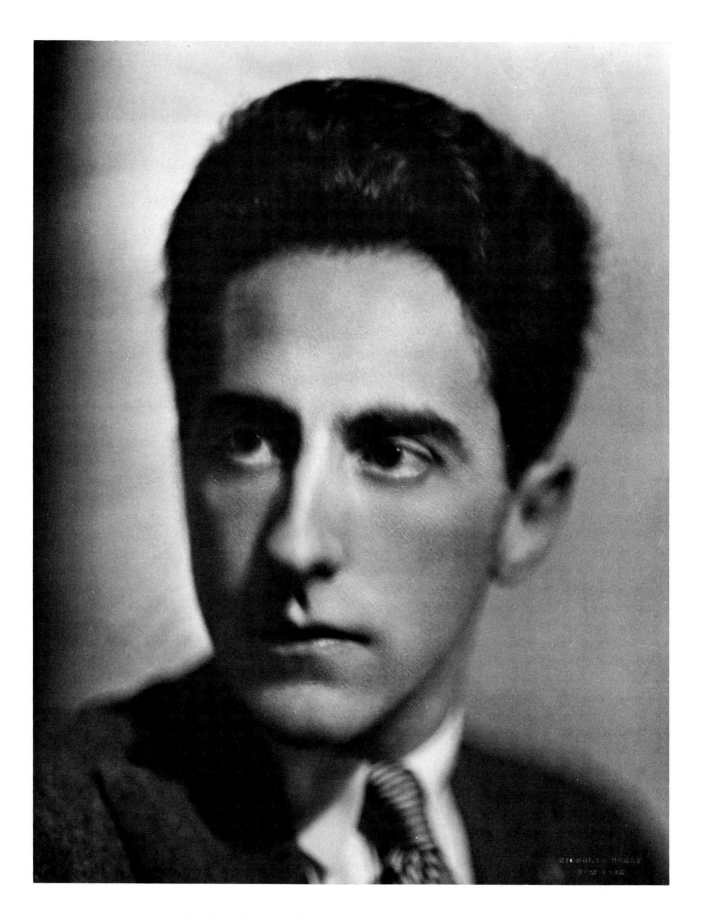

30 Jean Cocteau (1889–1963), writer, artist, film director.

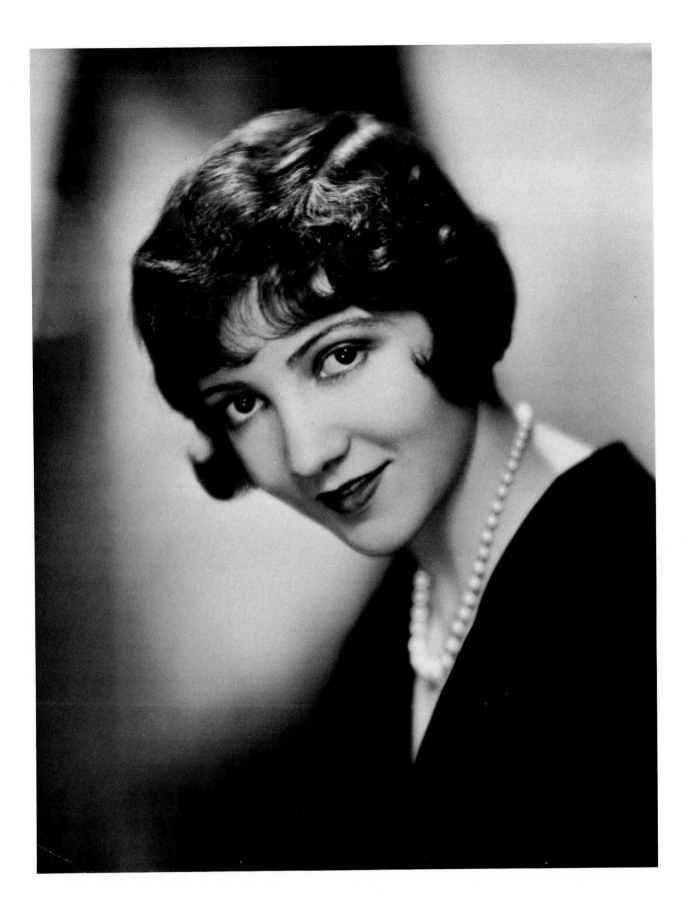

31 Claudette Colbert (born 1905), actress.

32 Jackie Coogan (born 1914), actor.

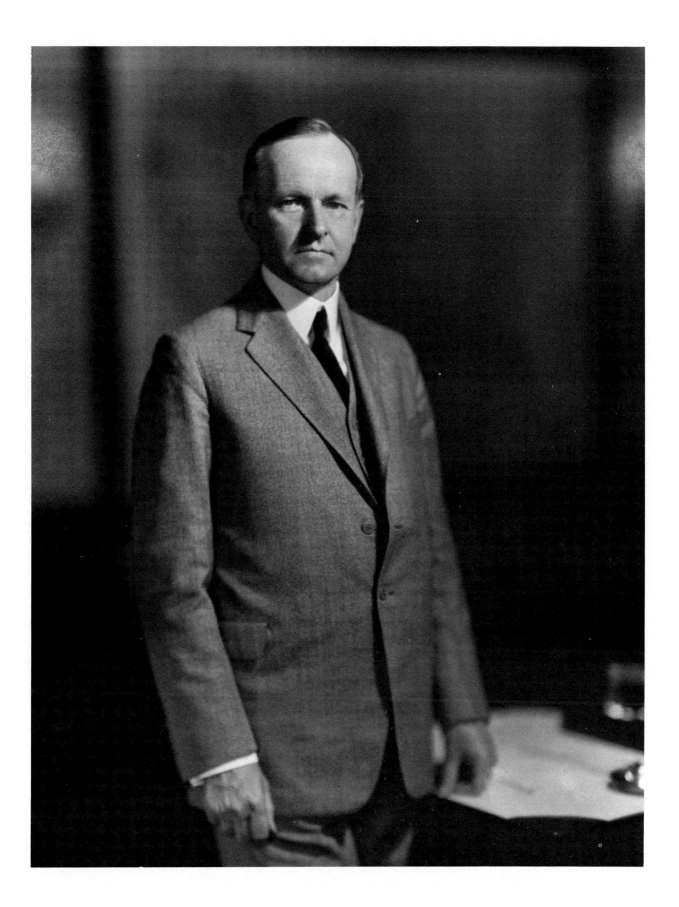

33 Calvin Coolidge (1872–1933), President of the United States.

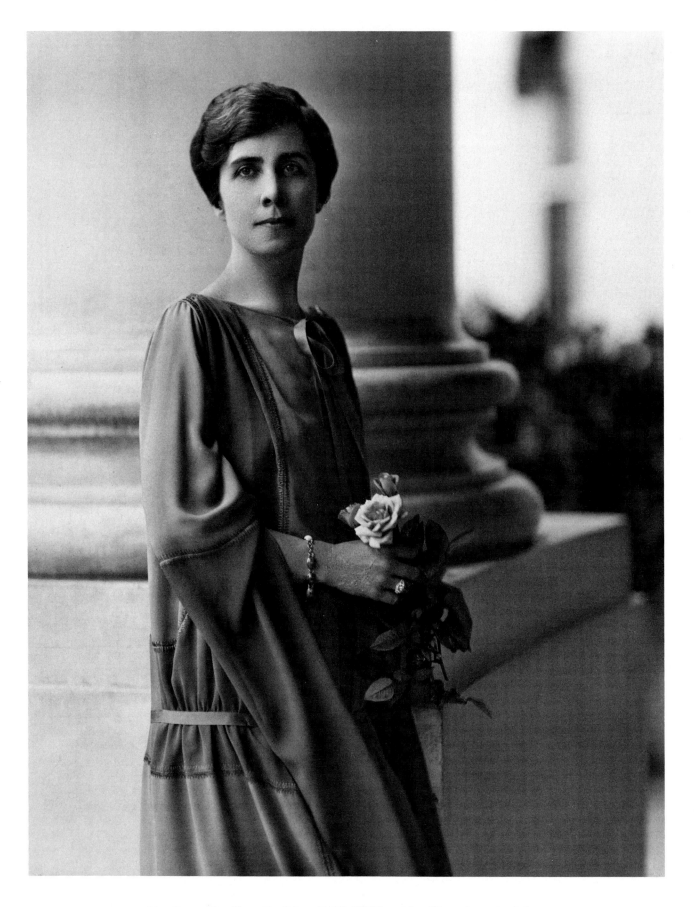

34 Grace Goodhue Coolidge (1879–1957), wife of President Coolidge.

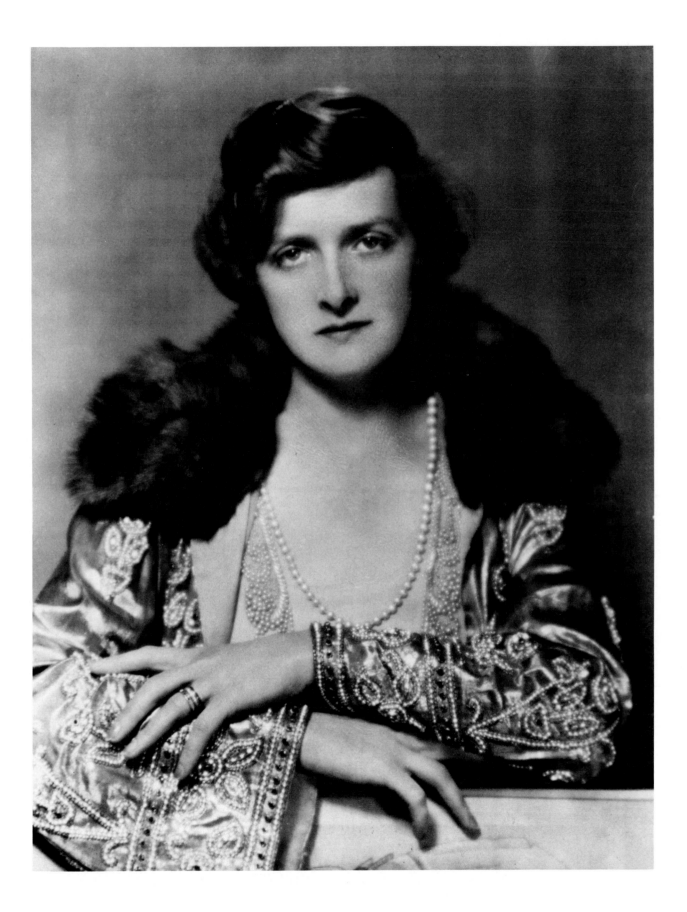

35 Gladys Cooper (1888–1971), actress.

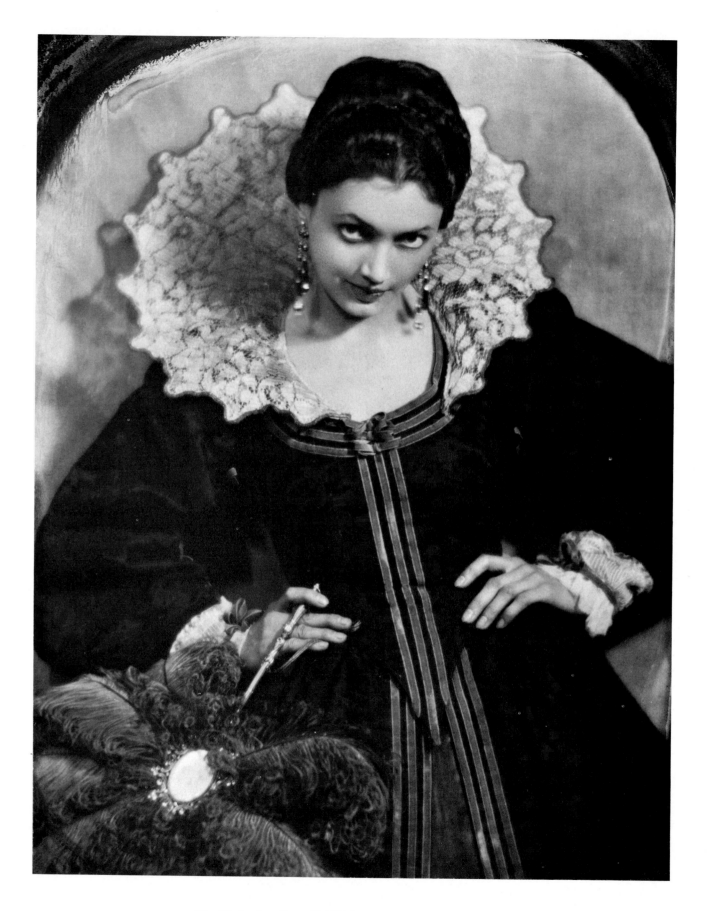

36 Katharine Cornell (1898–1974), actress, producer.

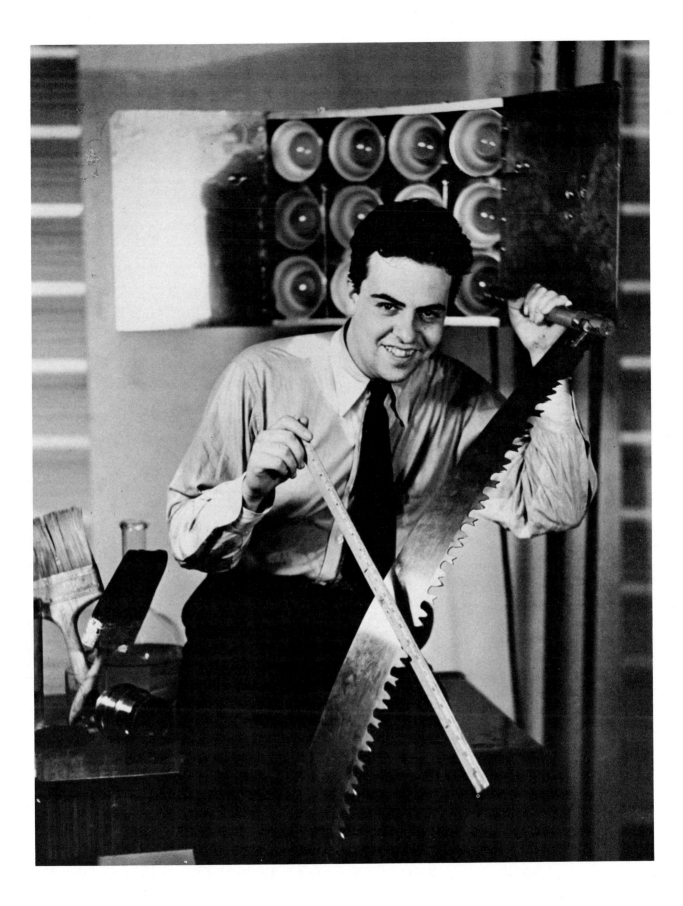

37 Miguel Covarrubias (1904–1957), artist, caricaturist, writer.

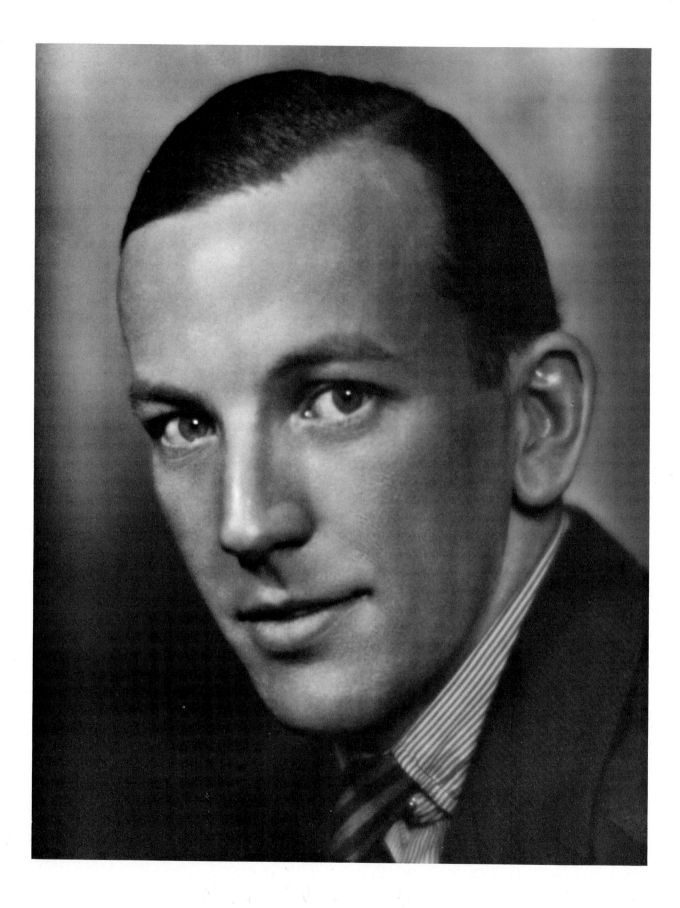

38 Noel Coward (1893–1973), actor, playwright.

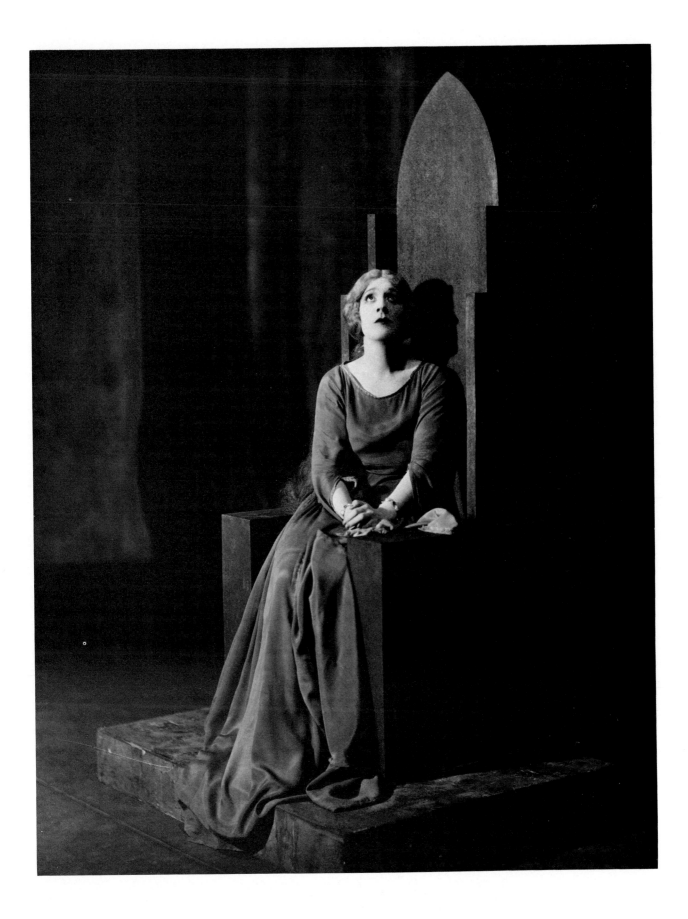

39 Jane Cowl (1887–1950), actress.

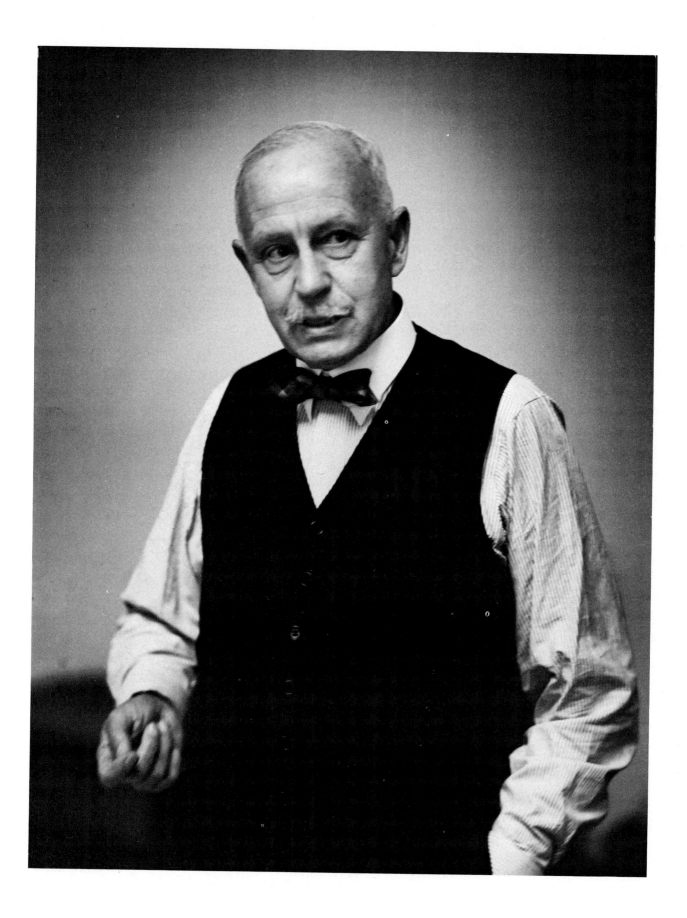

40 Frank Crowninshield (1872–1947), magazine editor.

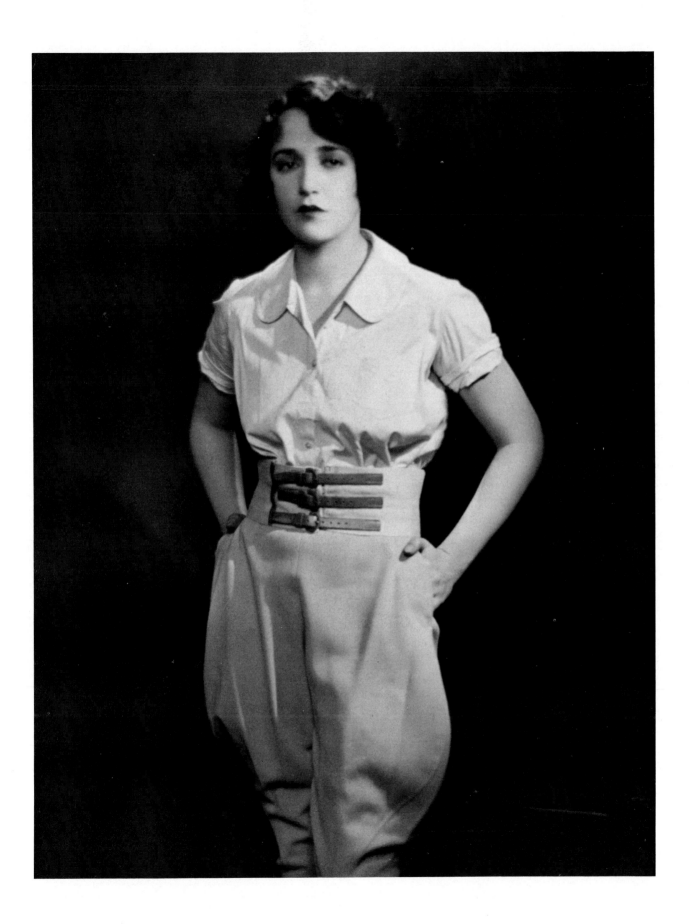

41 Bebe Daniels (1901–1971), actress, popular singer.

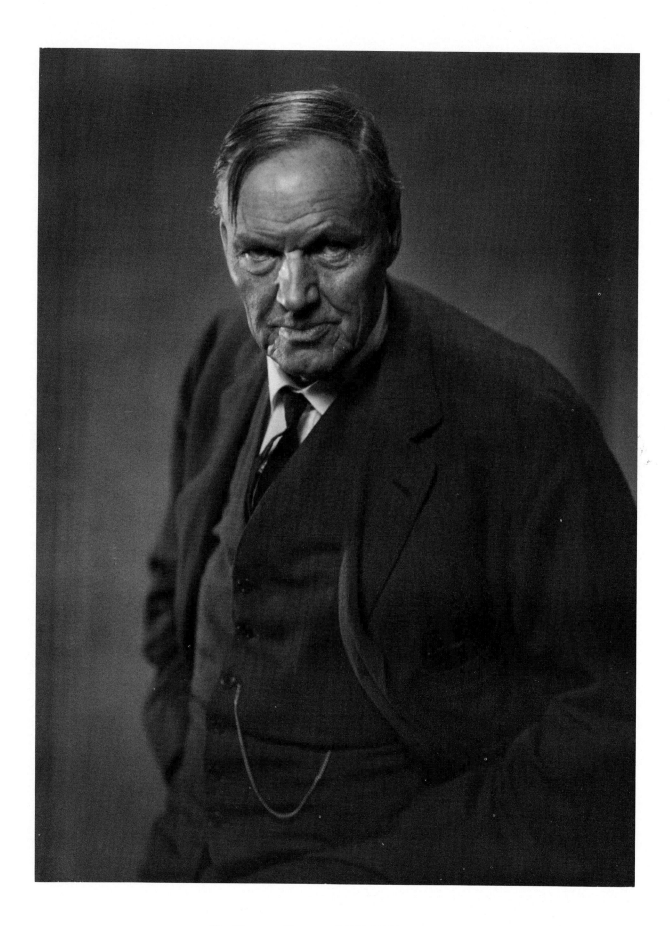

42 Clarence Darrow (1857–1938), attorney.

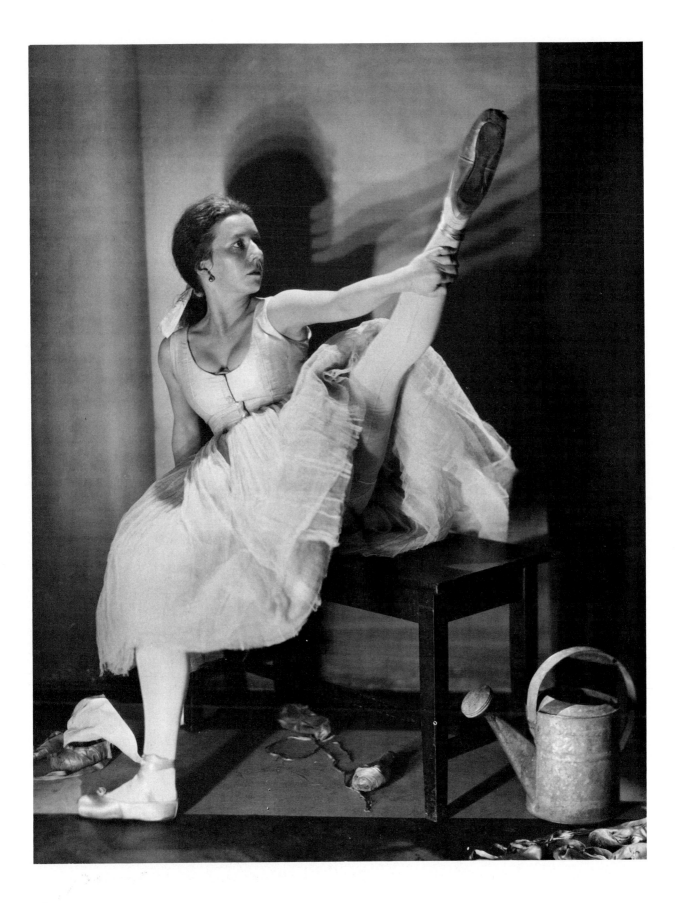

43 Agnes DeMille (born ca. 1905), ballet dancer, choreographer.

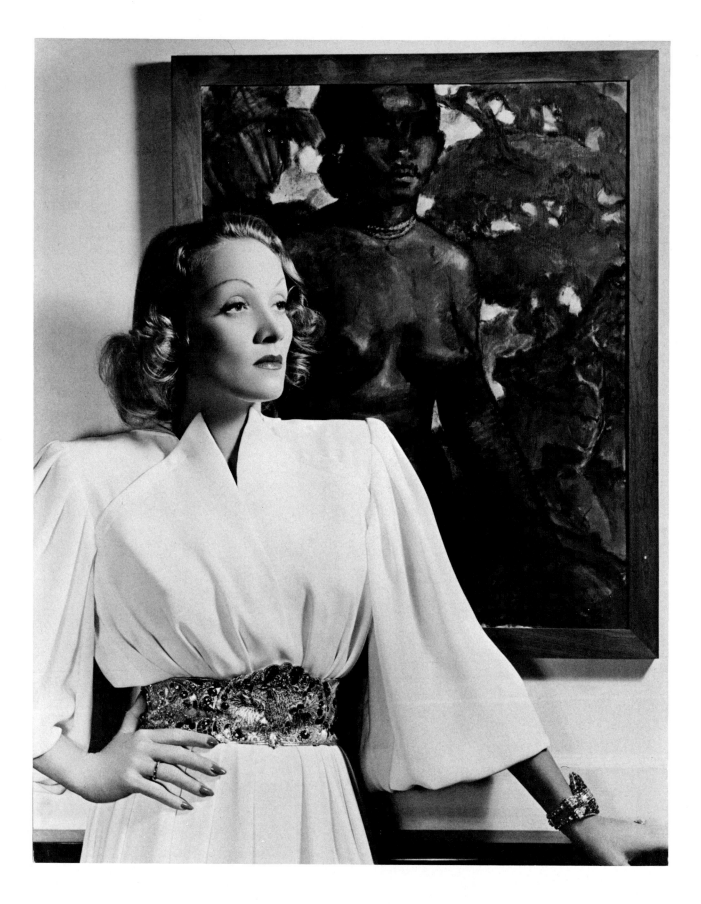

44 Marlene Dietrich (born 1901), actress, chanteuse.

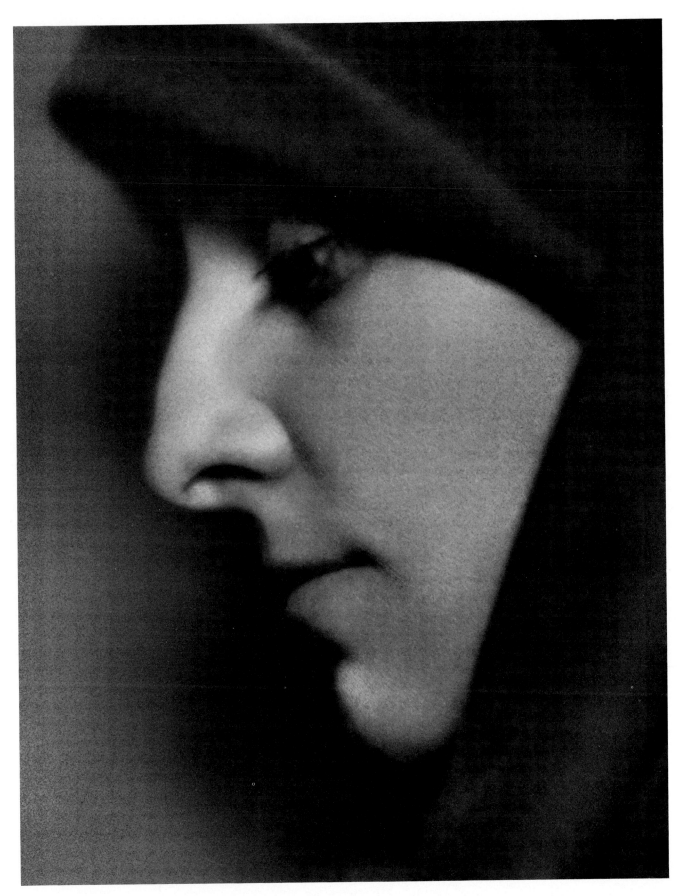

45 Ruth Draper (1884–1956), monologist.

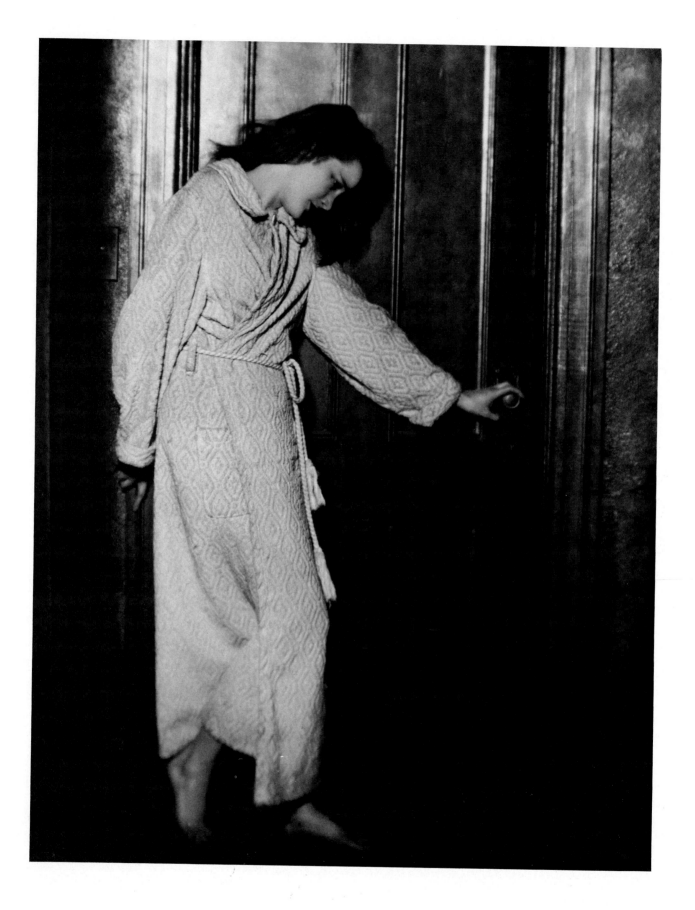

46 Jeanne Eagels (1894–1929), actress.

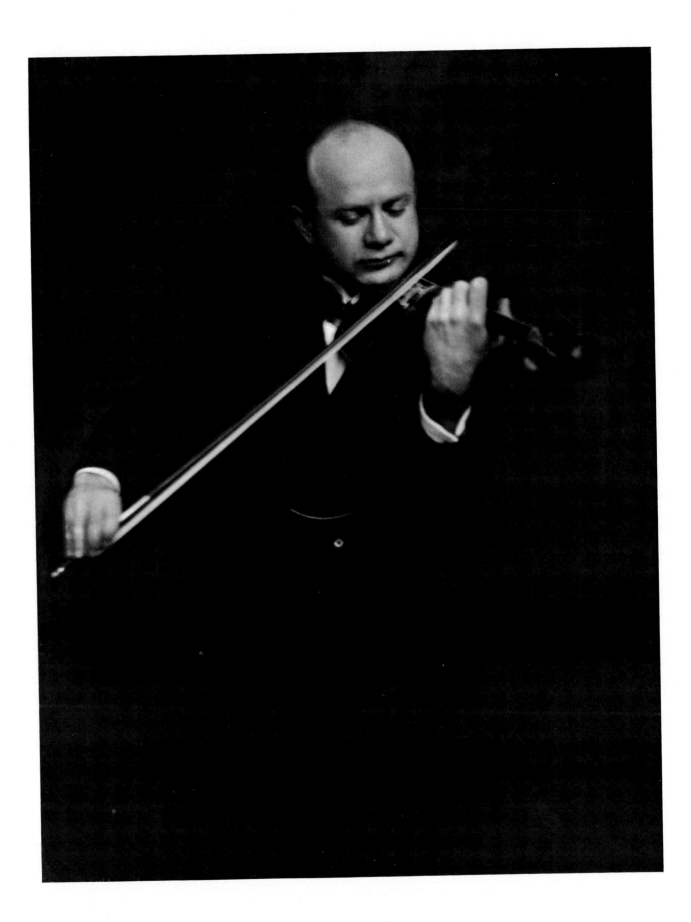

47 Mischa Elman (1891–1967), violinist.

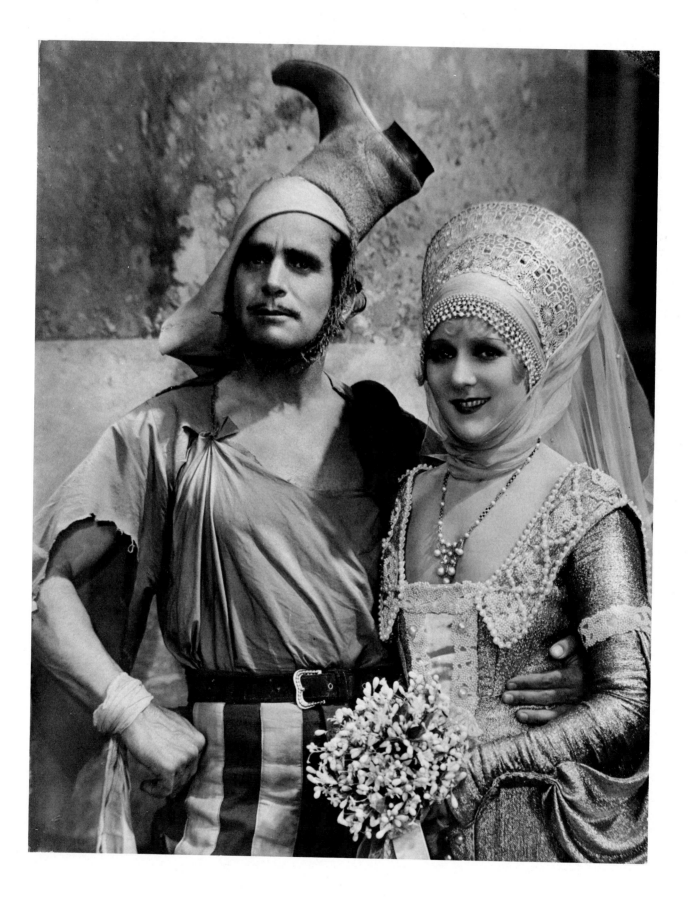

48　Douglas Fairbanks, Sr. (1883–1939) and Mary Pickford (born 1894), actors and film producers.

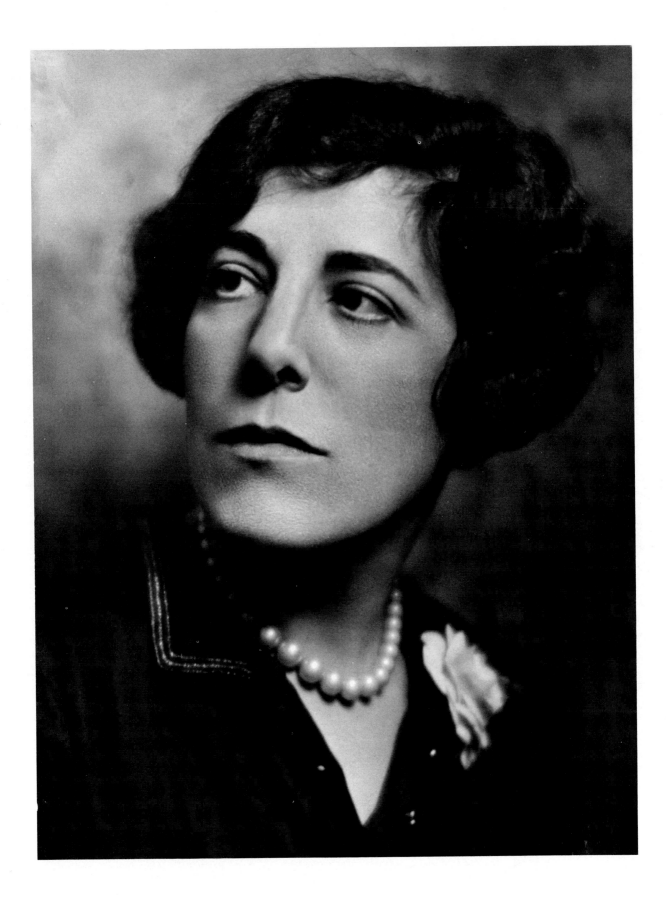

49 Edna Ferber (1887–1968), novelist.

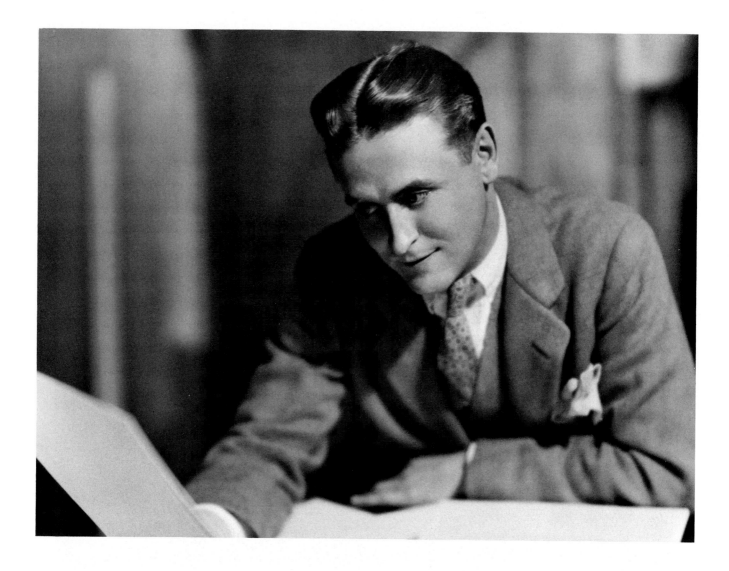

50 F. Scott Fitzgerald (1896–1940), novelist.

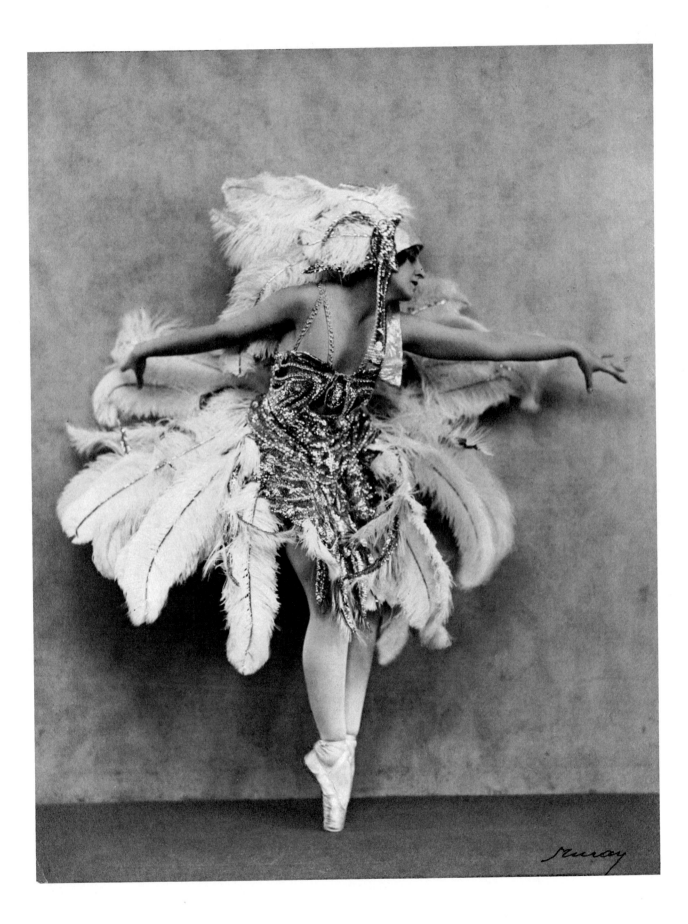

51 Vera Fokina (1886–1958), ballerina.

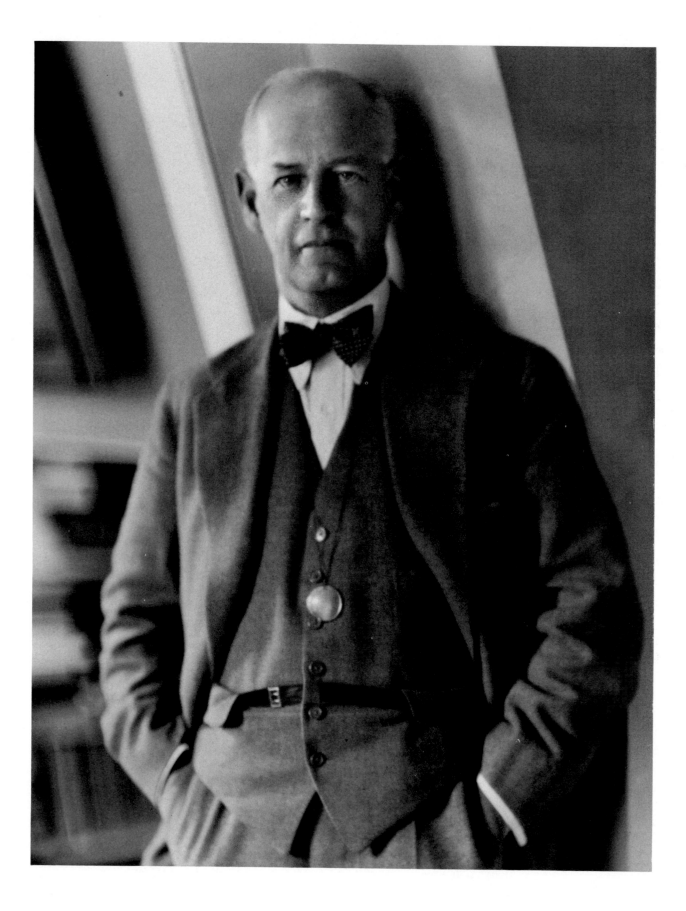

52 John Galsworthy (1867–1933), author.

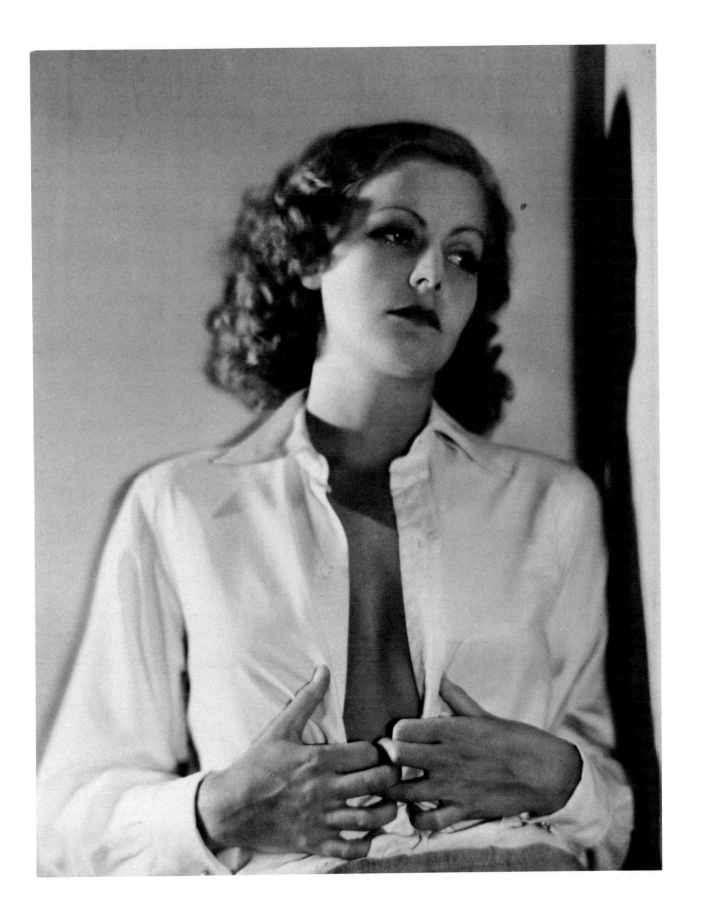

53 Greta Garbo (born 1905), film actress.

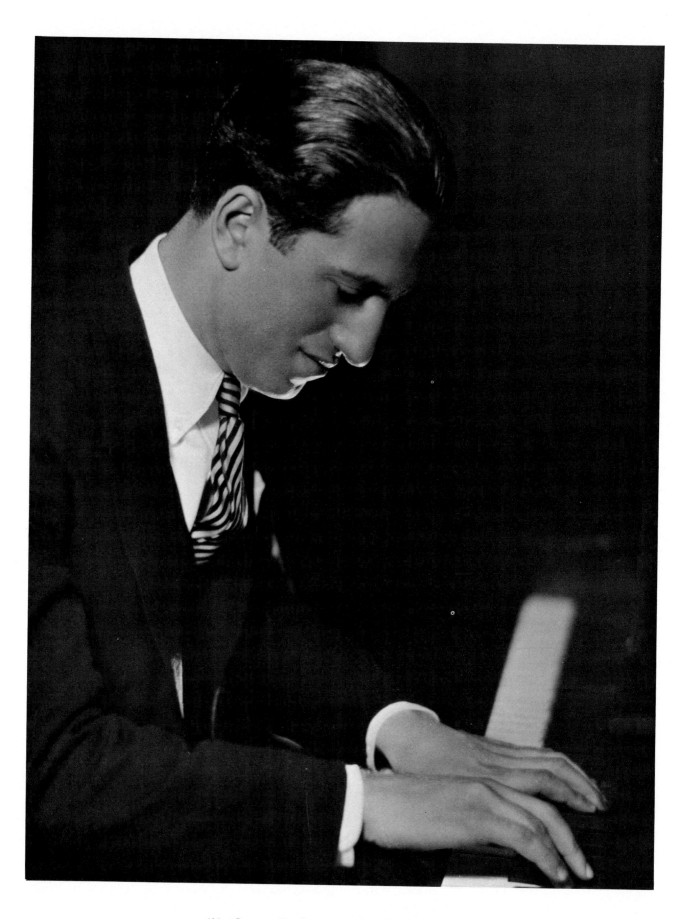

54 George Gershwin (1898–1937), composer.

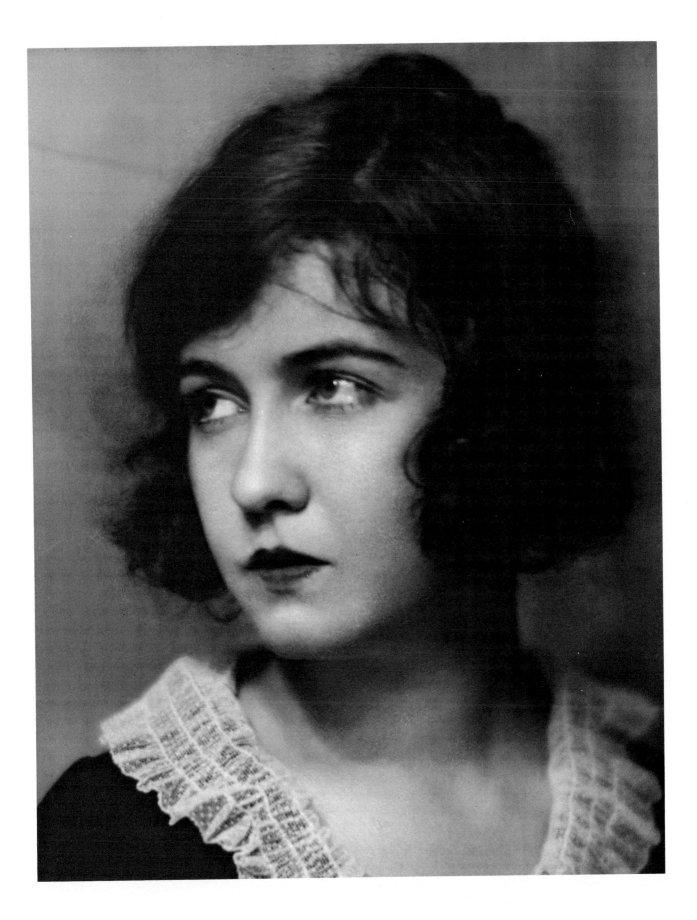

55 Dorothy Gish (1898–1968), actress.

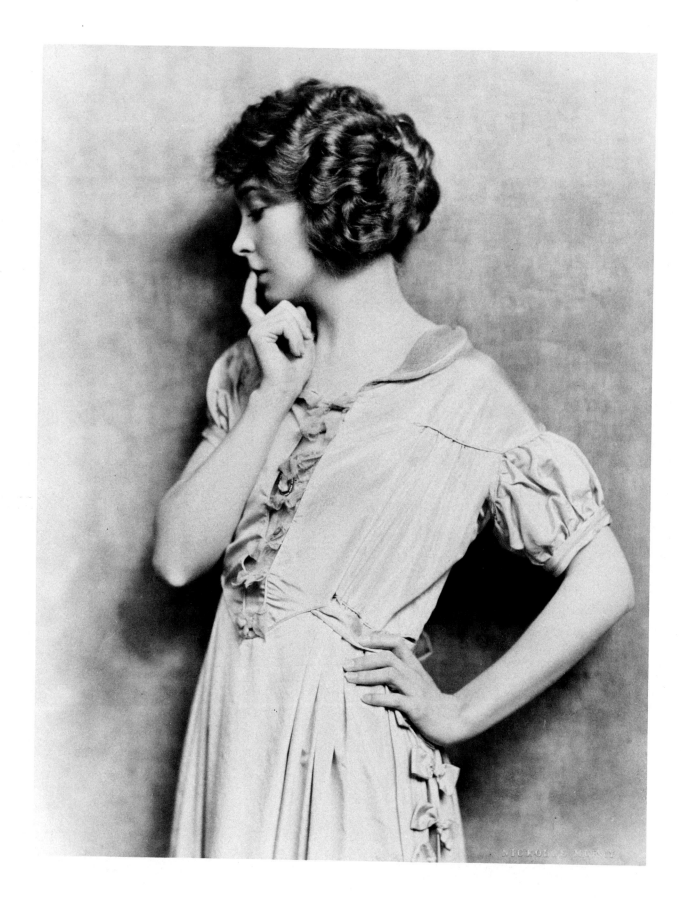

56　Lillian Gish (born 1896), actress.

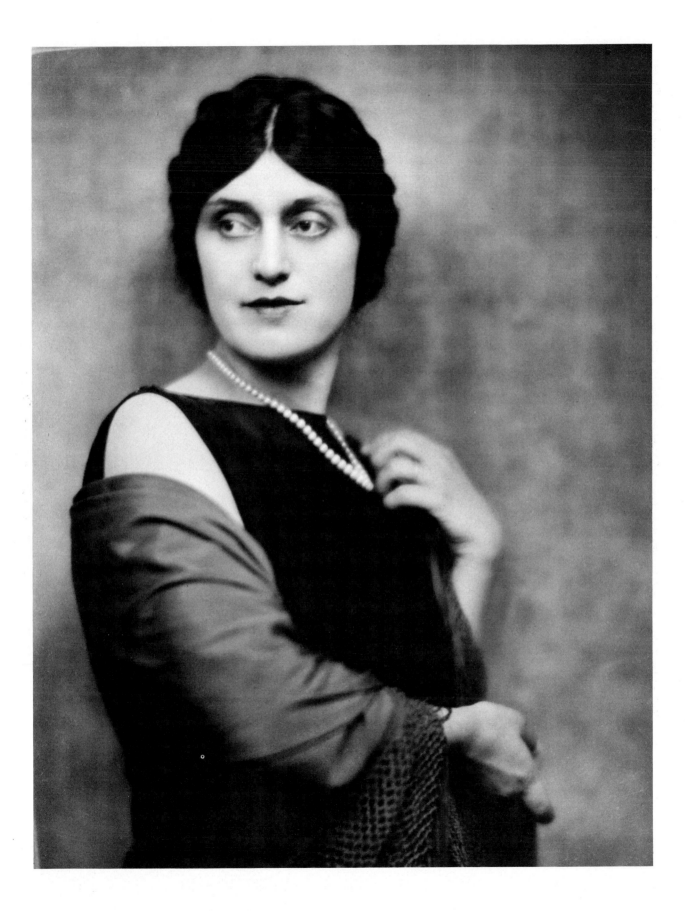

57 Alma Gluck (1884–1938), operatic soprano.

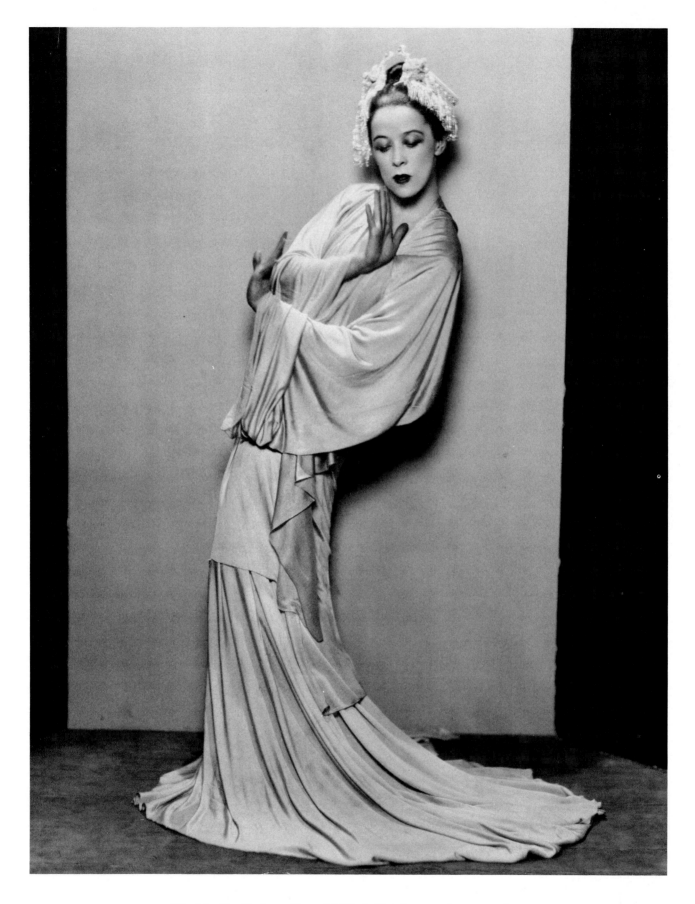

58 Martha Graham (born 1894), ballet dancer, choreographer.

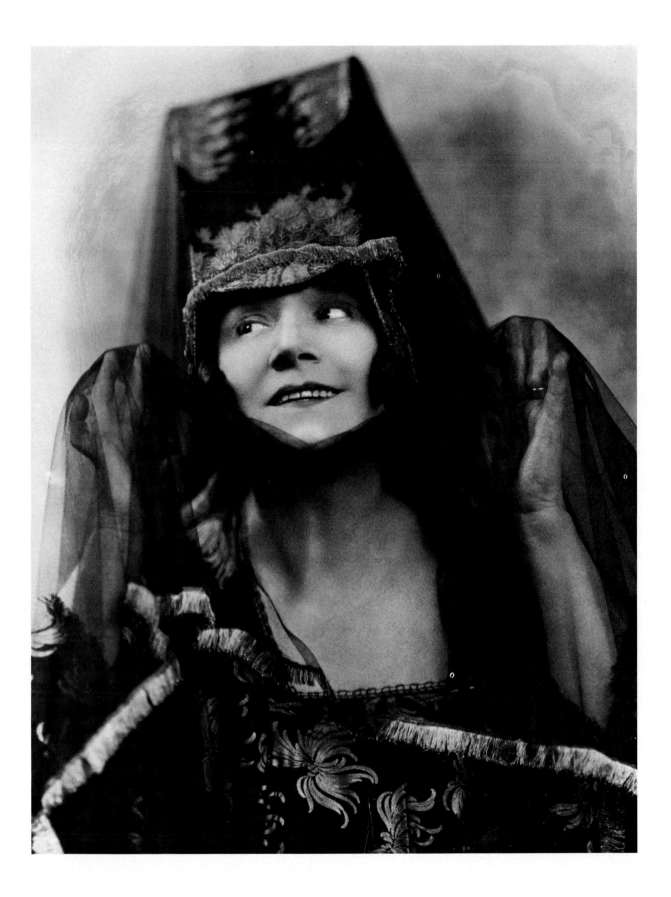

59 Yvette Guilbert (1868–1944), diseuse, actress.

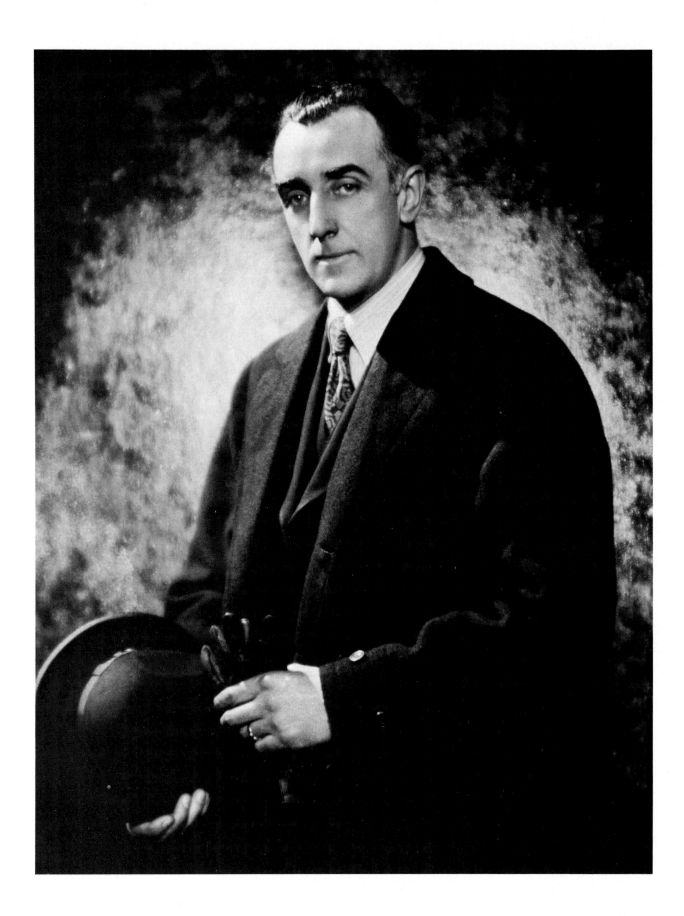

60 Walter Hampden (1879–1955), actor.

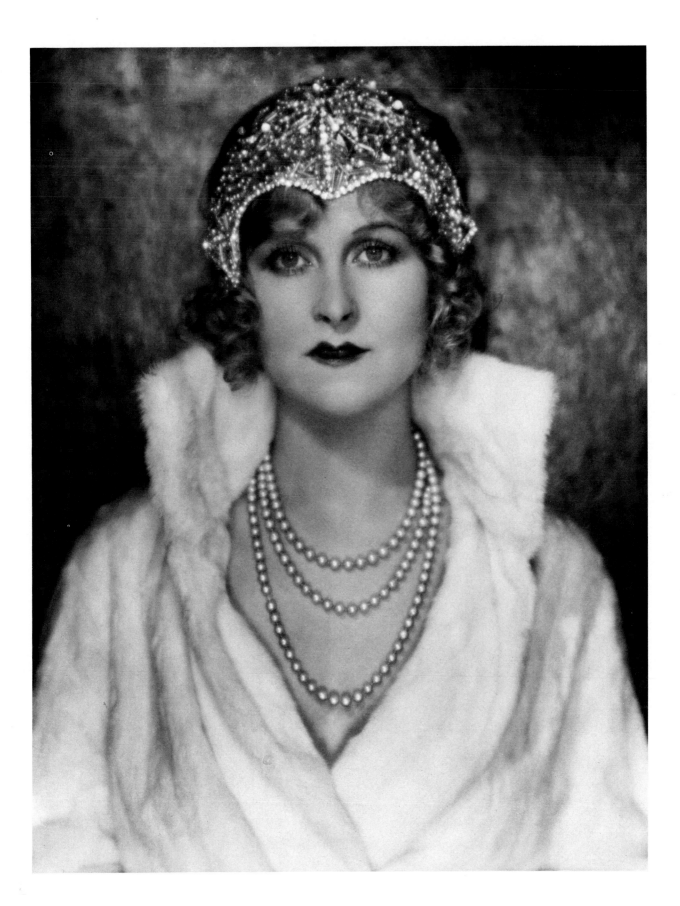

61 Hope Hampton (born 1901), actress, socialite, would-be opera singer.

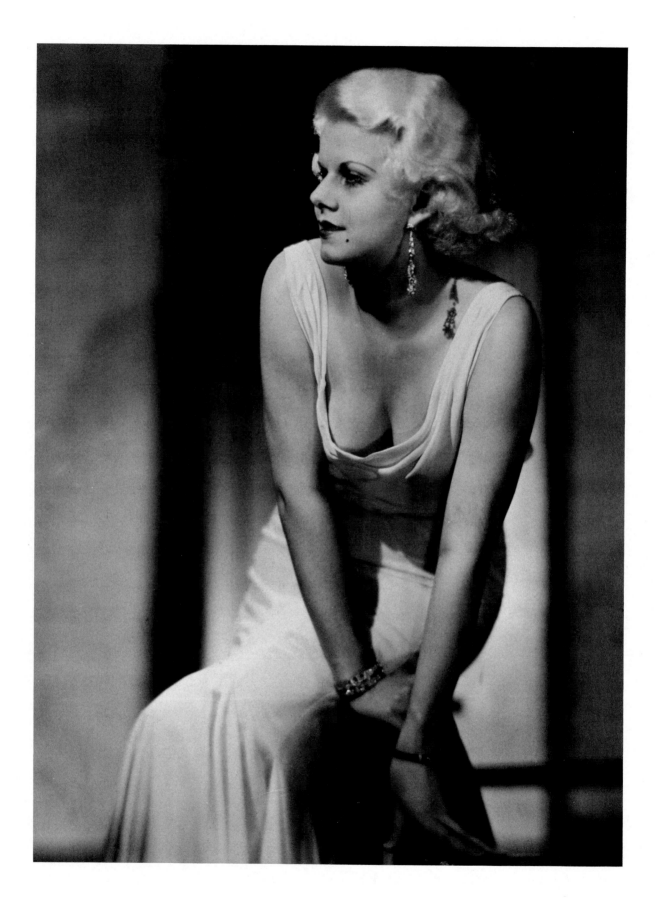

62 Jean Harlow (1911–1937), film actress.

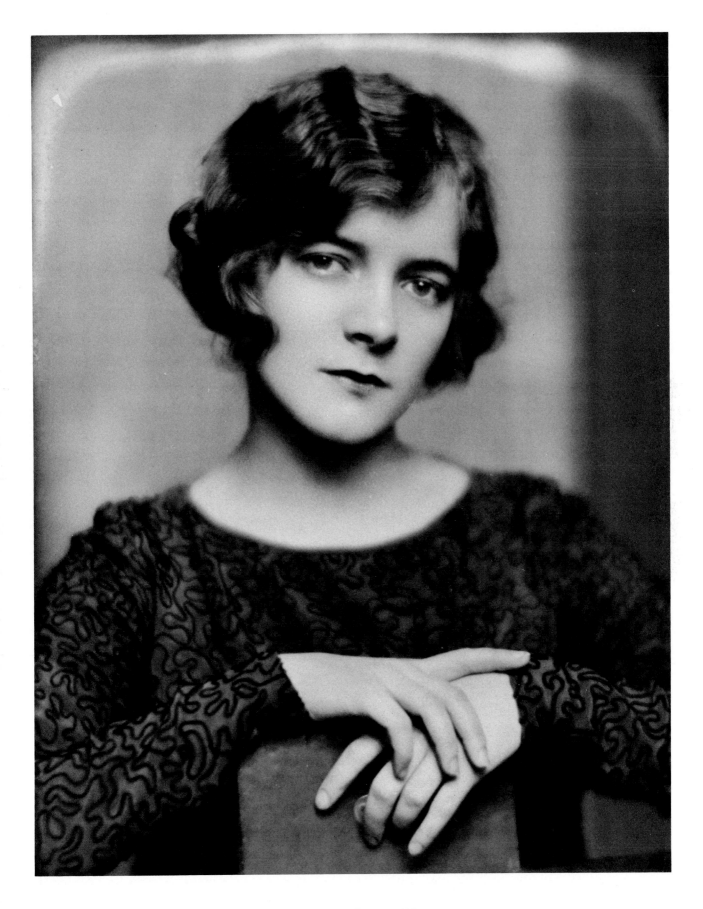

63 Helen Hayes (born 1900), actress.

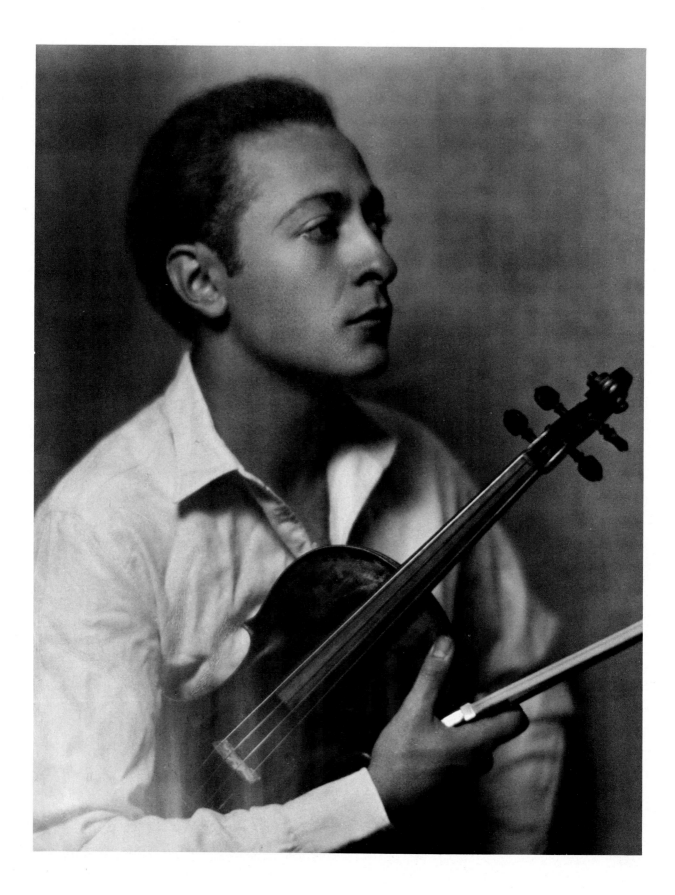

64 Jascha Heifetz (born 1901), violinist.

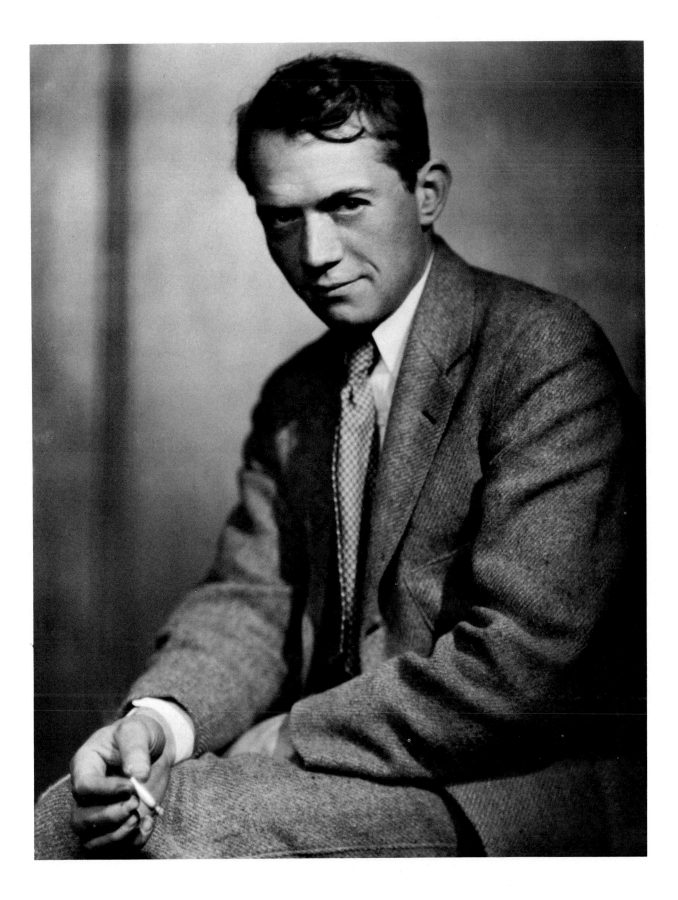

65 John Held, Jr. (1889–1958), cartoonist.

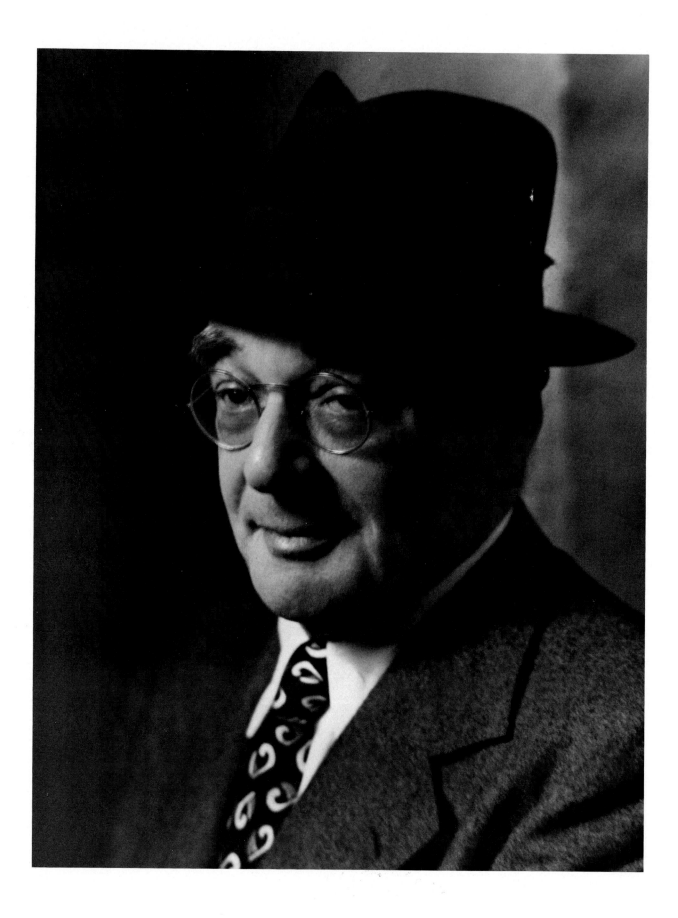

66 Joseph Hergesheimer (1880–1954), novelist.

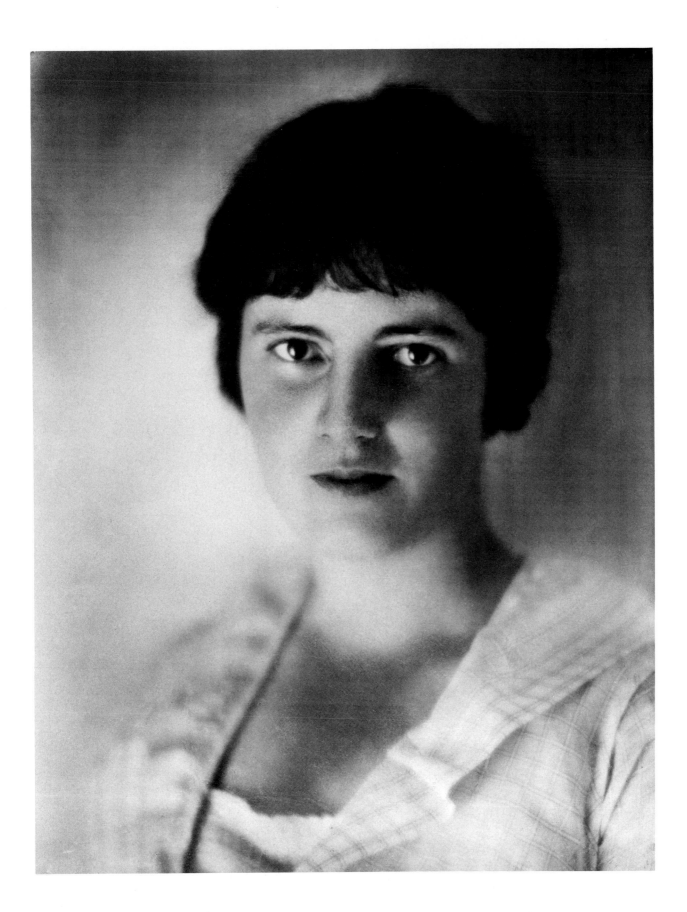

67 Louise Homer Stires (1896-1970), operatic soprano.

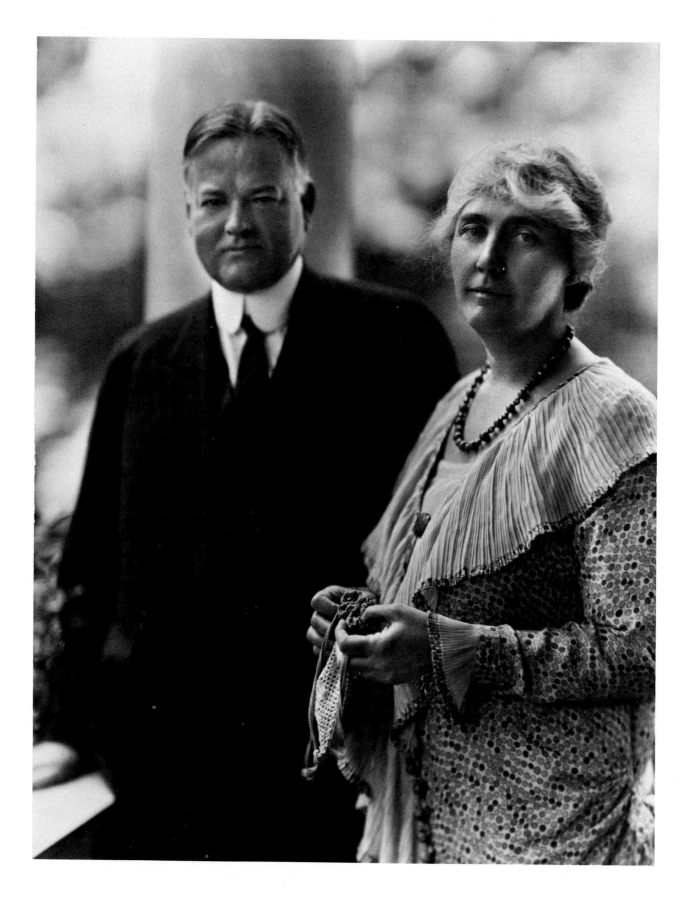

68 Herbert Hoover (1874–1964), President of the United States,
and Mrs. Lou Henry Hoover (1875–1944).

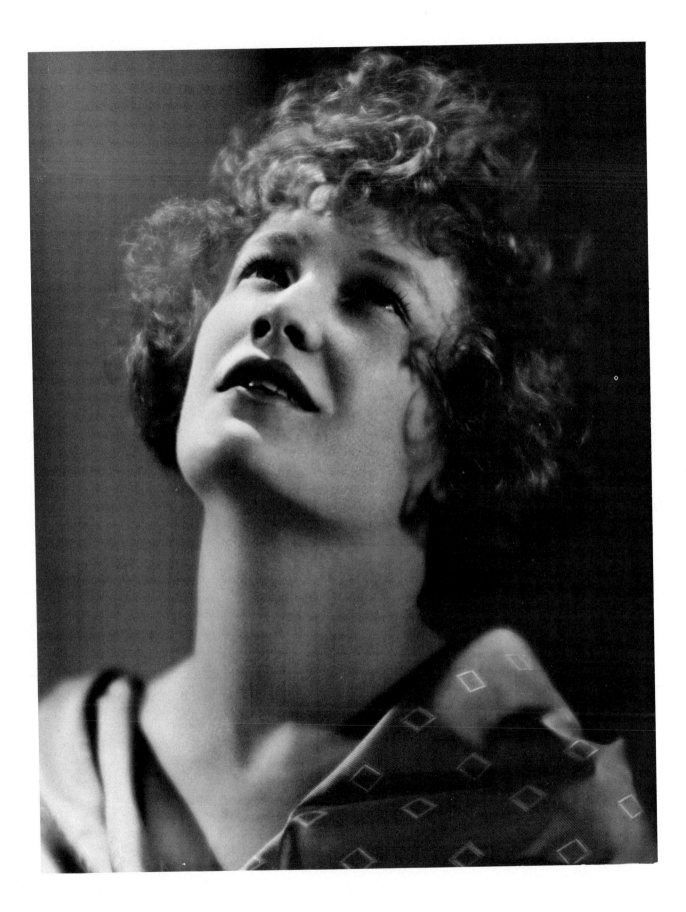

69 Miriam Hopkins (1902–1972), actress.

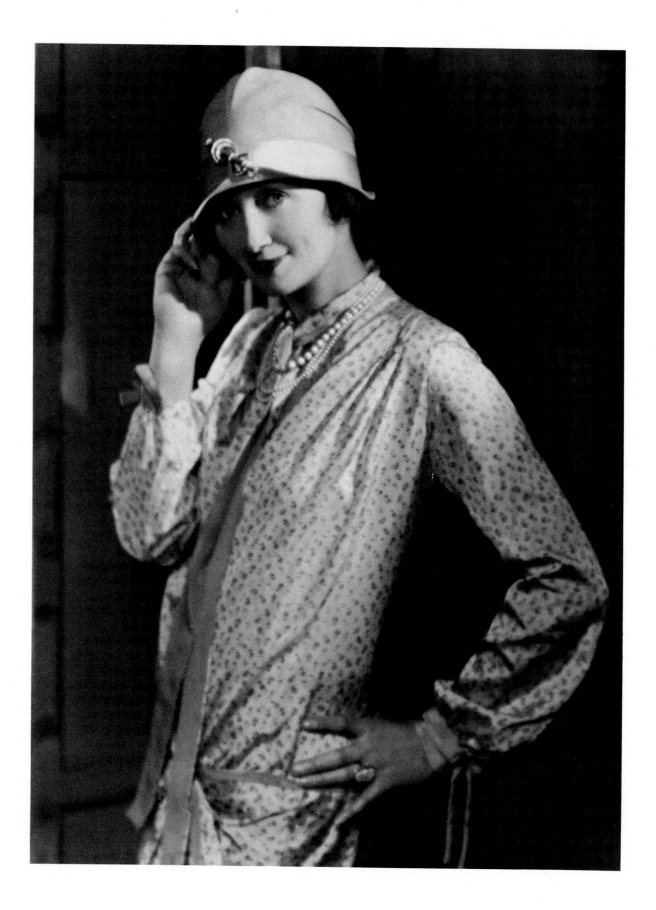

70 Hedda Hopper (1890–1966), columnist, film actress.

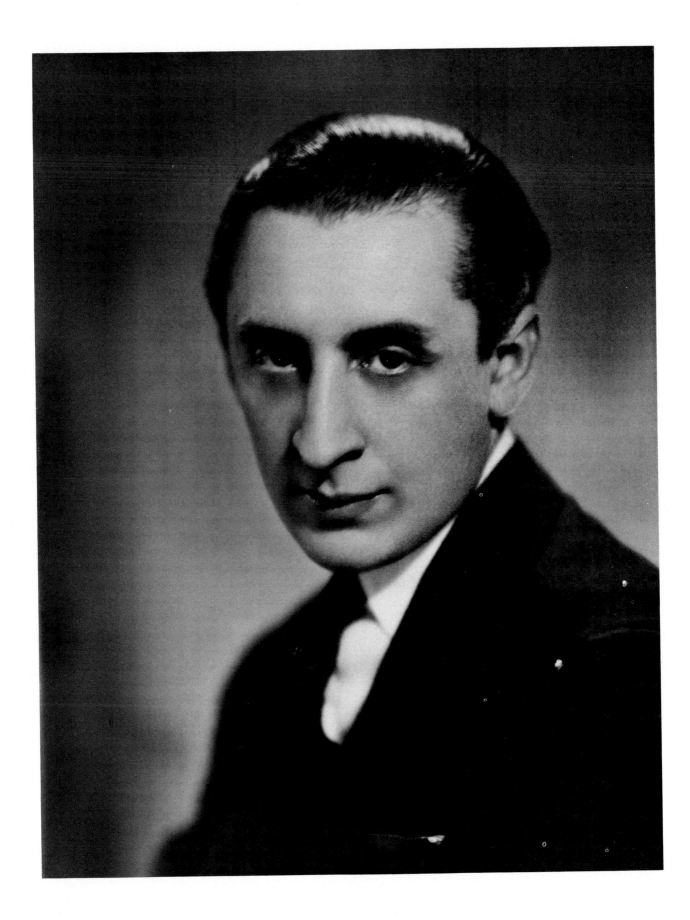

71 Vladimir Horowitz (born 1904), pianist.

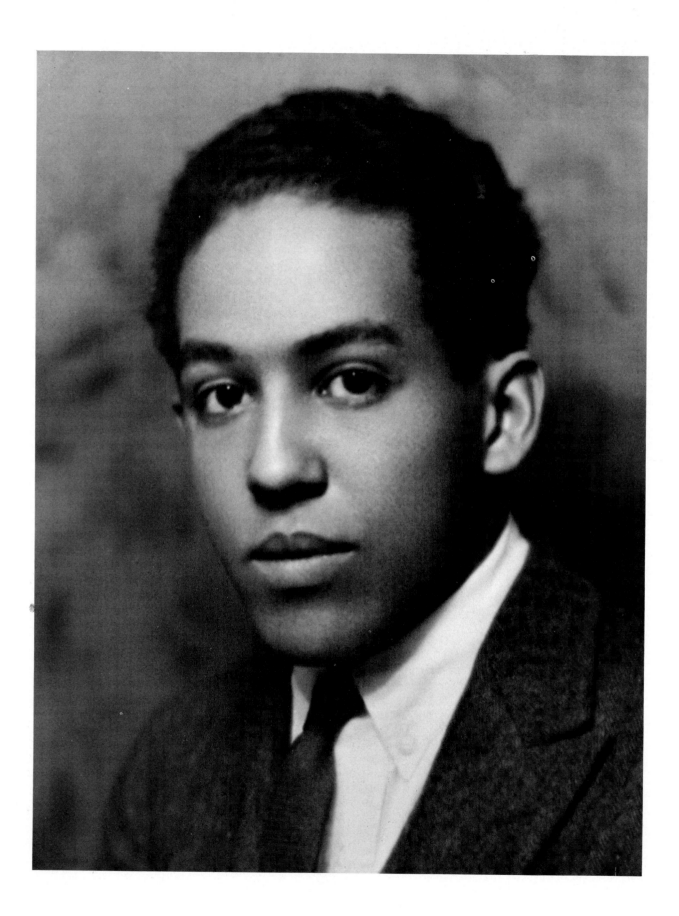

72 Langston Hughes (1902–1967), author.

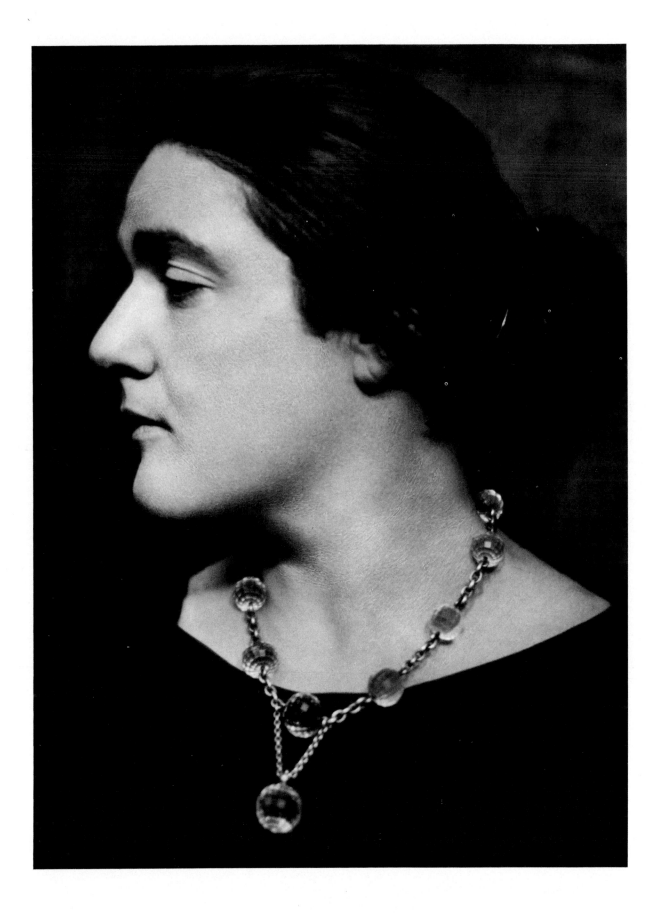

73 Fannie Hurst (1889–1968), novelist.

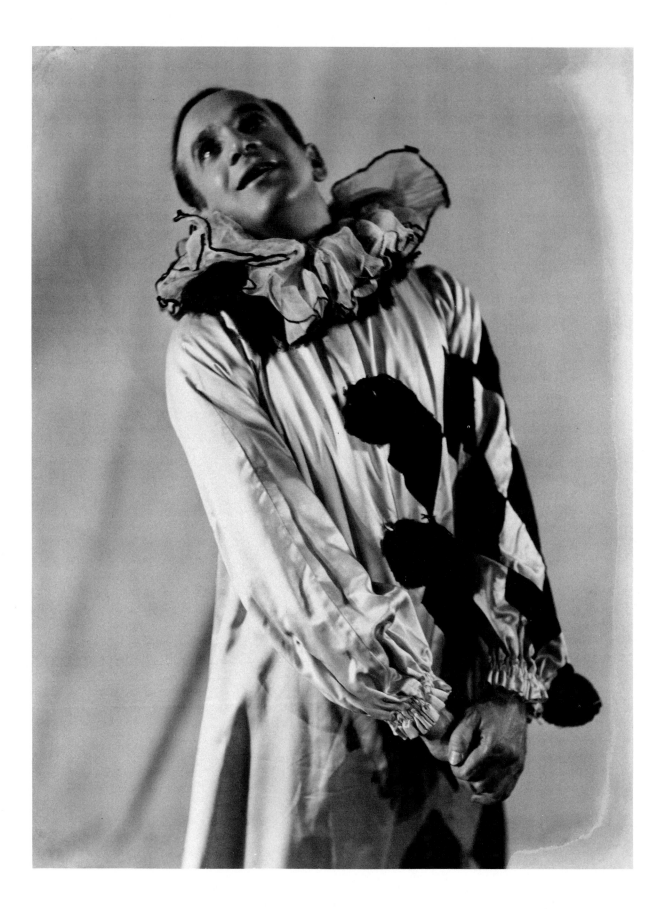

74 Al Jolson (1886–1950), popular singer, actor.

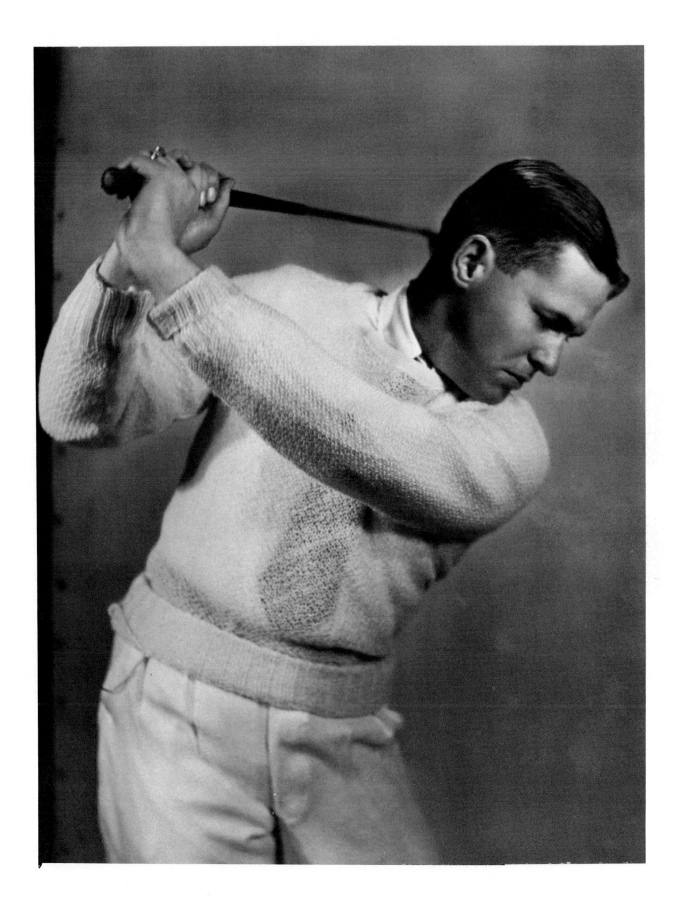

75 Bobby Jones (Robert Tyre Jones, Jr., 1902–1971), golfer.

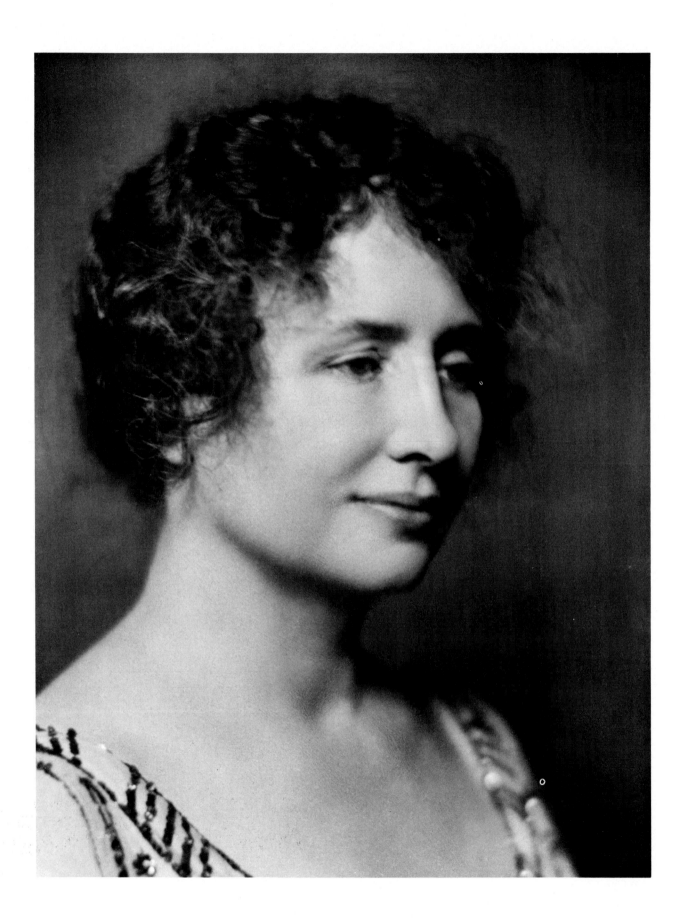

76 Helen Keller (1880–1968), blind author.

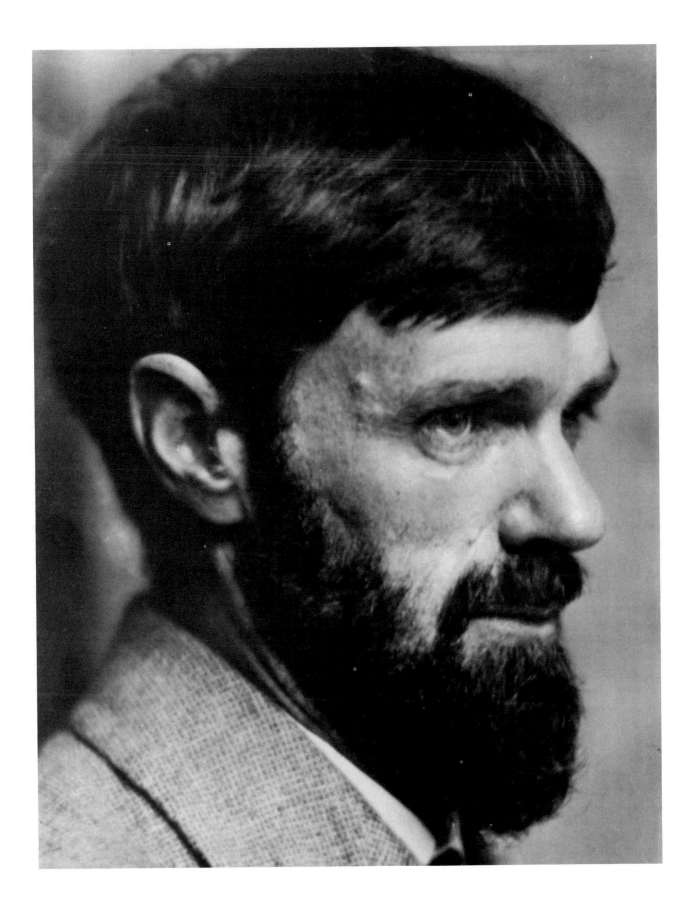

77 D. H. Lawrence (1885–1930), novelist.

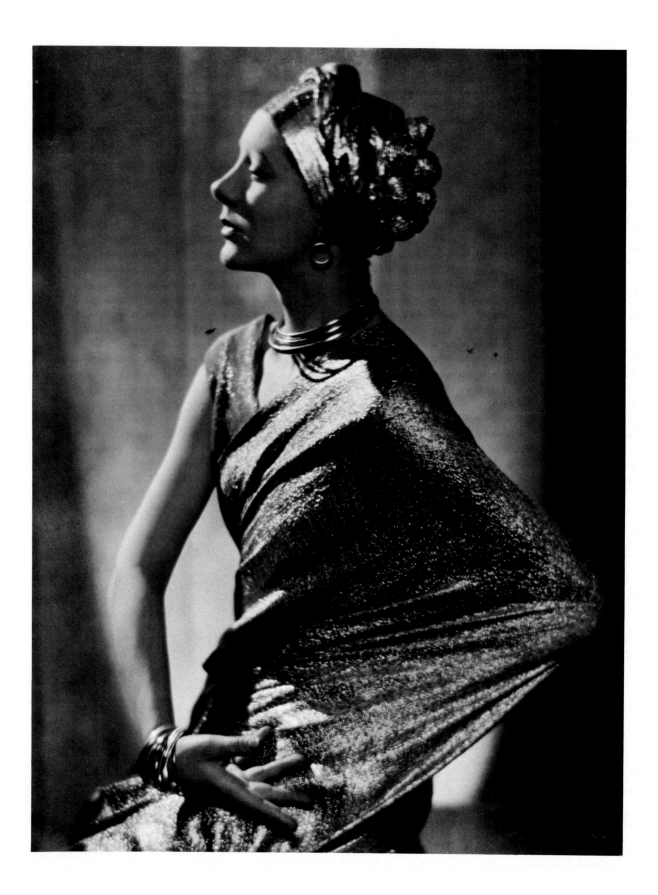

78 Gertrude Lawrence (1898–1952), actress, popular singer.

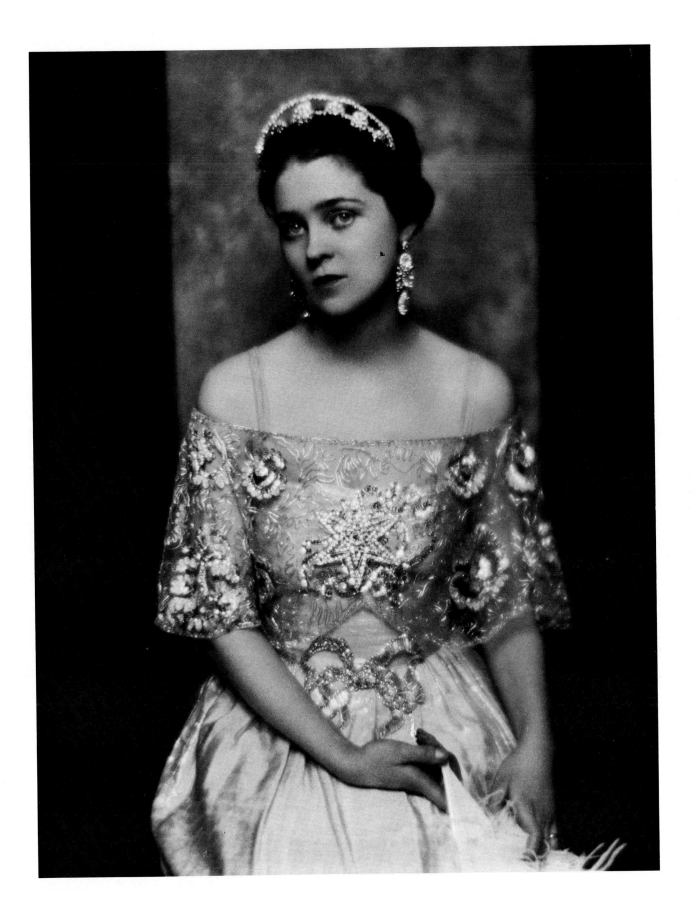

79 Eva Le Gallienne (born 1899), actress, producer.

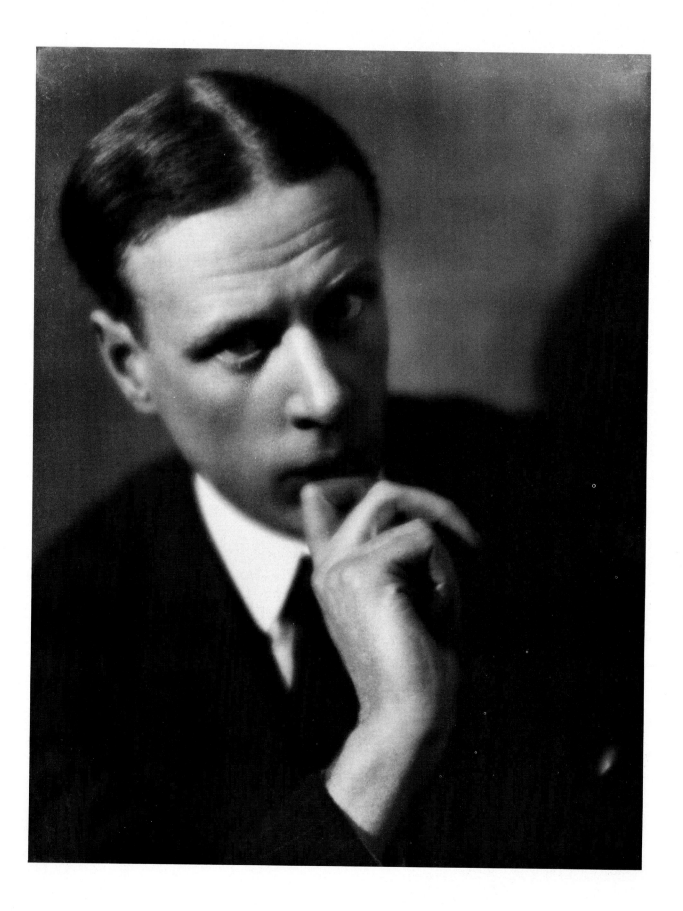

80 Sinclair Lewis (1884–1951), novelist.

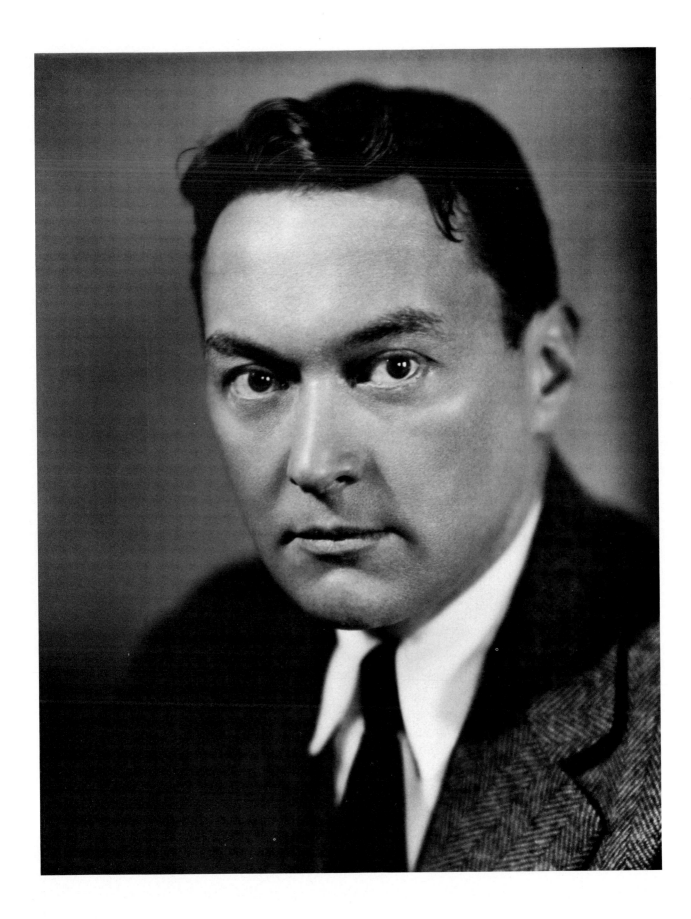

81 Walter Lippmann (1889–1974), columnist.

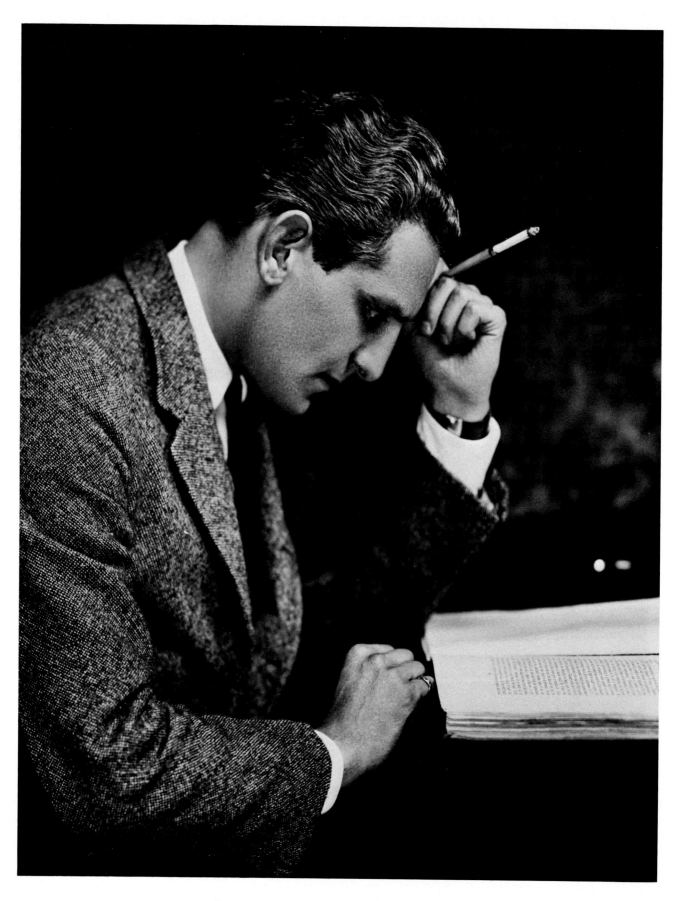

82 Horace Liveright (1886–1933), publisher.

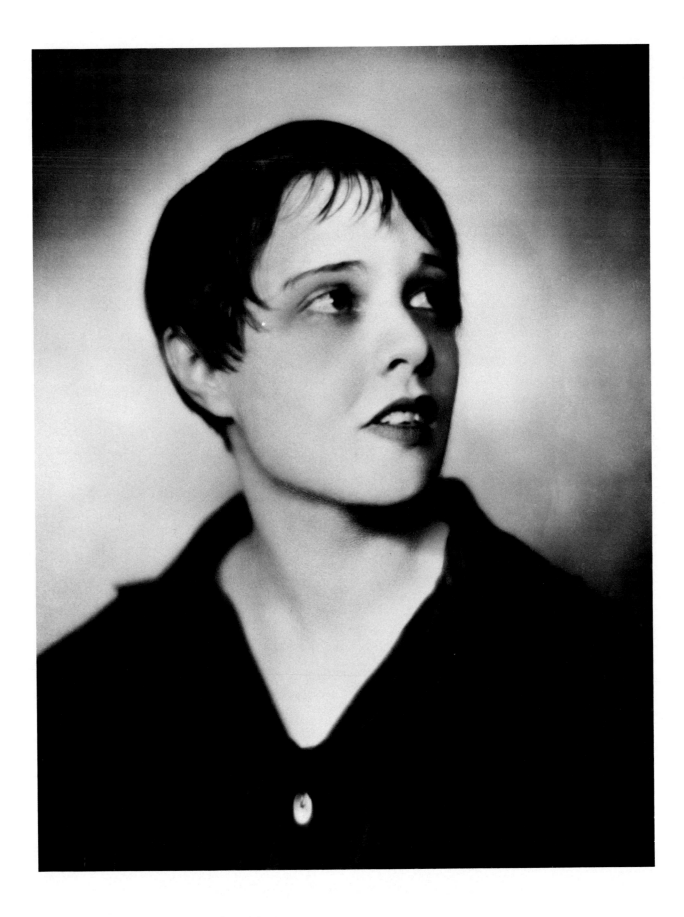

83 Anita Loos (born 1893), author.

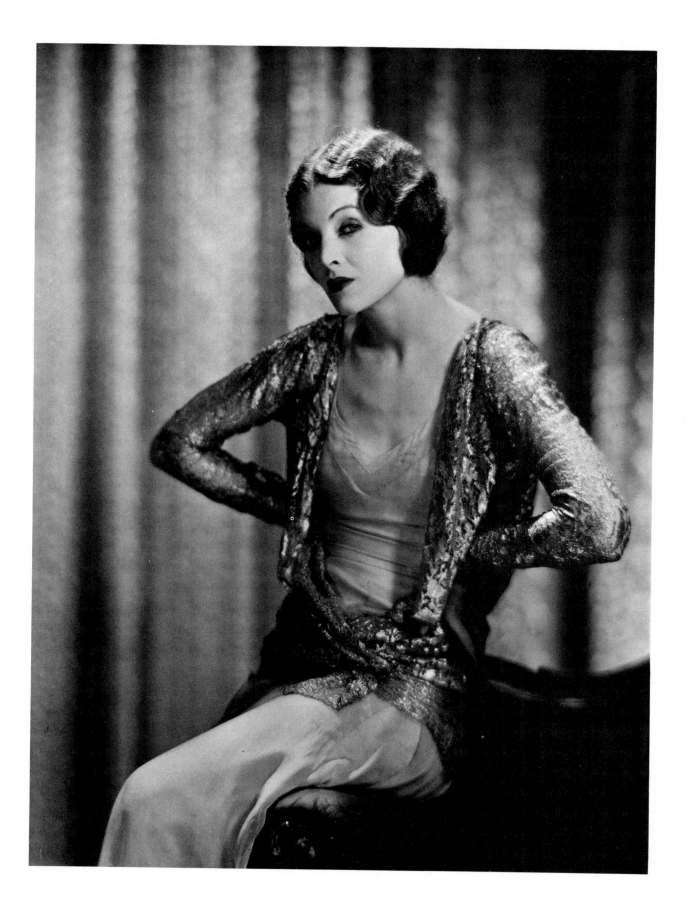

84 Myrna Loy (born 1905), film actress.

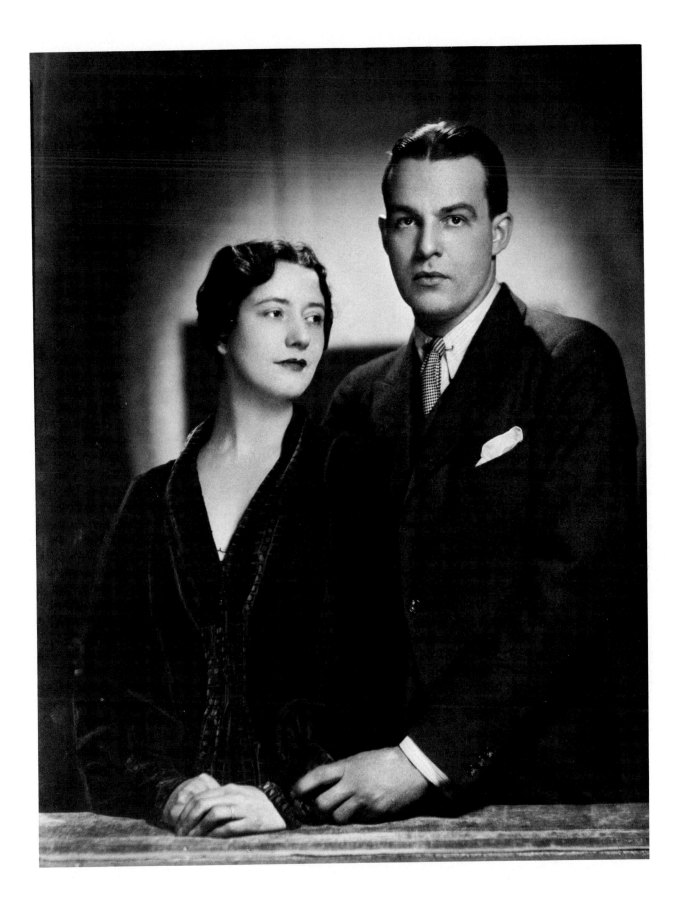

85 The Lunts: Lynn Fontanne (born ca. 1887) and Alfred Lunt (1892–1977), actors.

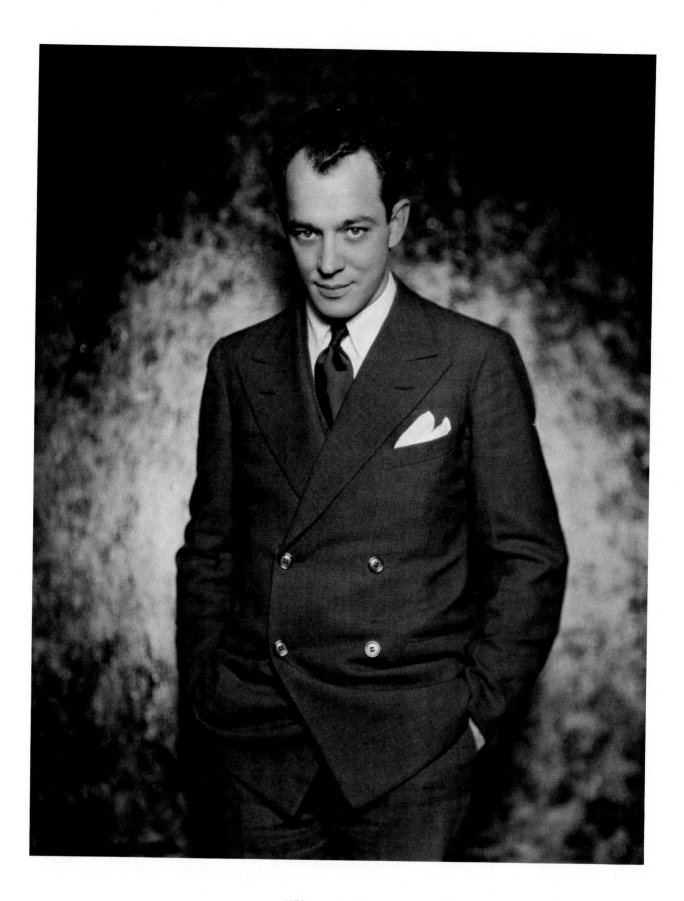

86 Charles MacArthur (1895–1956), playwright.

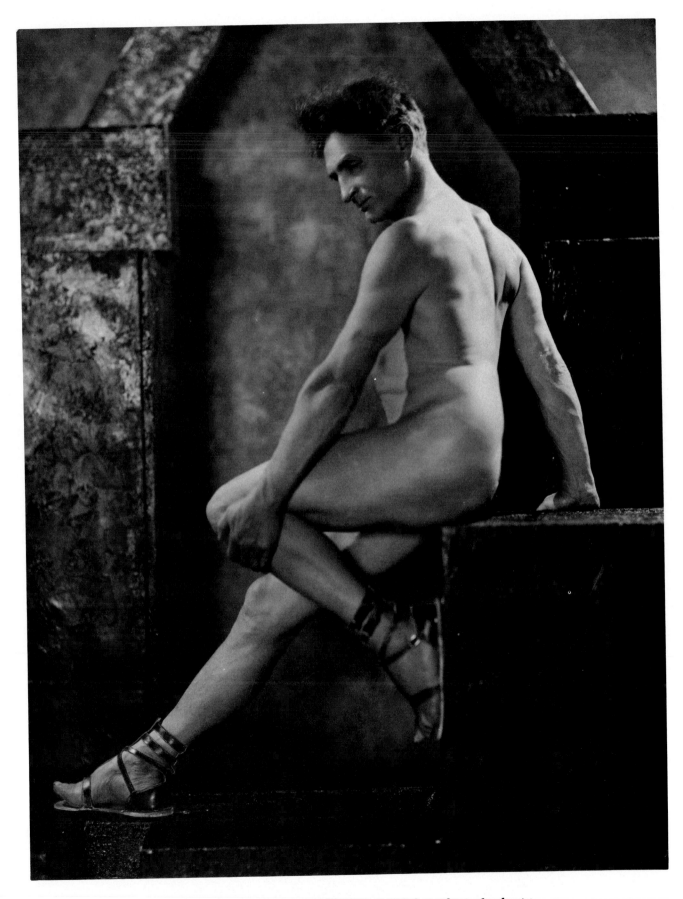

87 Bernarr Macfadden (1868–1955), publisher, physical culturist.

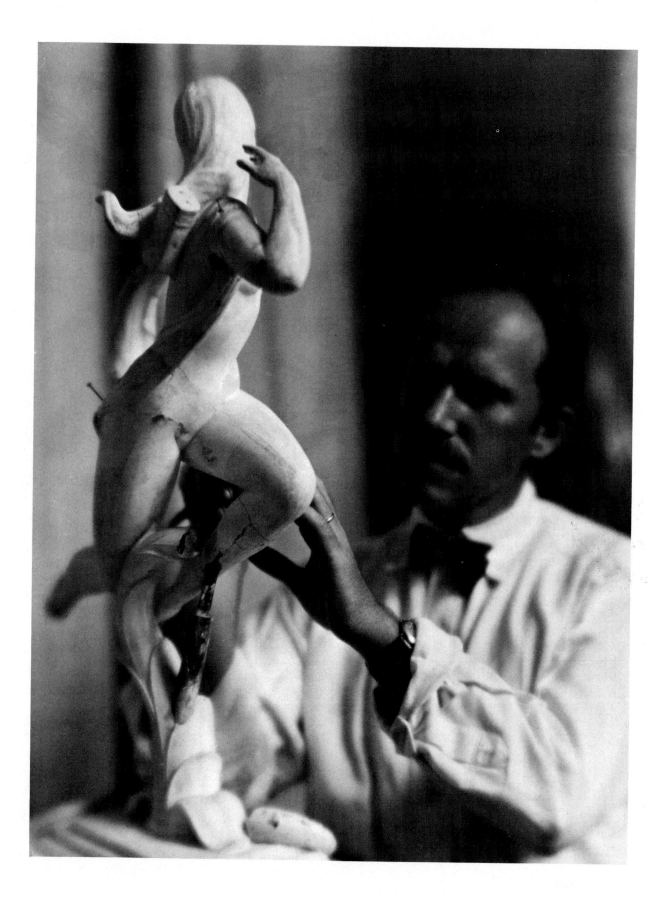

88 Paul Manship (1885–1966), sculptor.

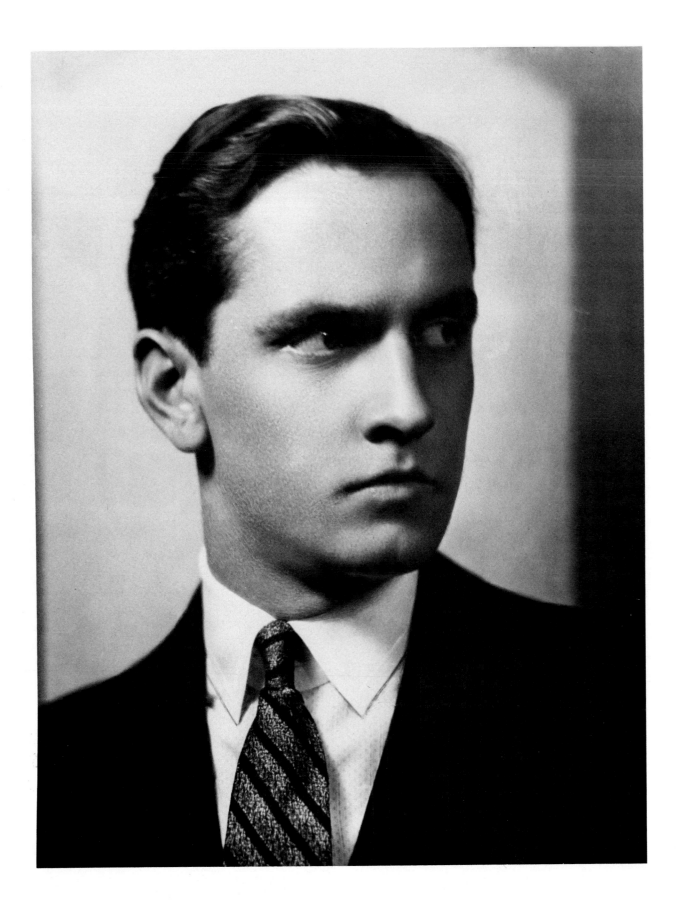

89 Fredric March (1897–1975), actor.

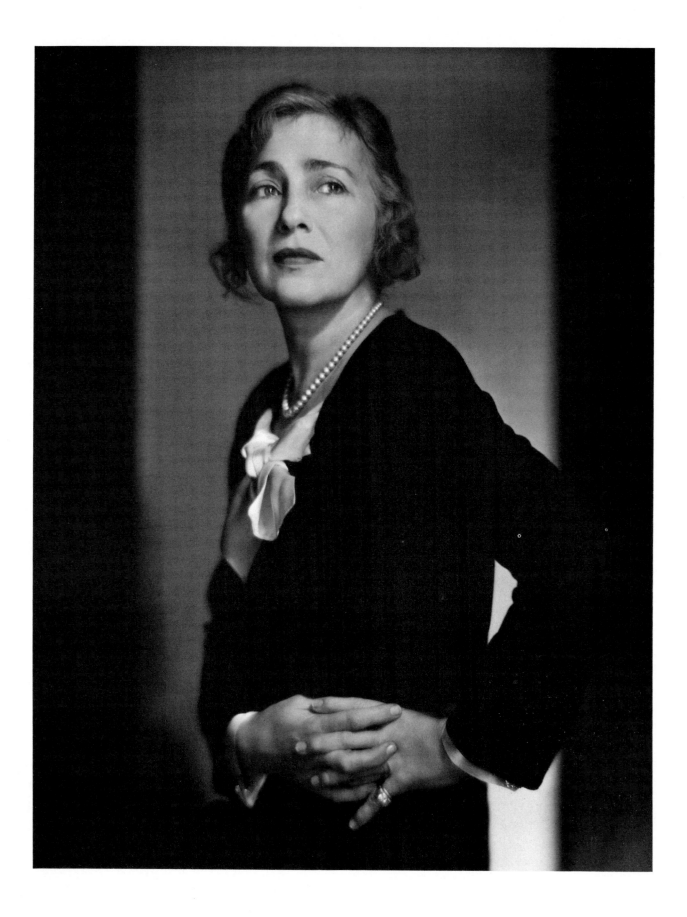

90 Neysa McMein (1890–1949), illustrator.

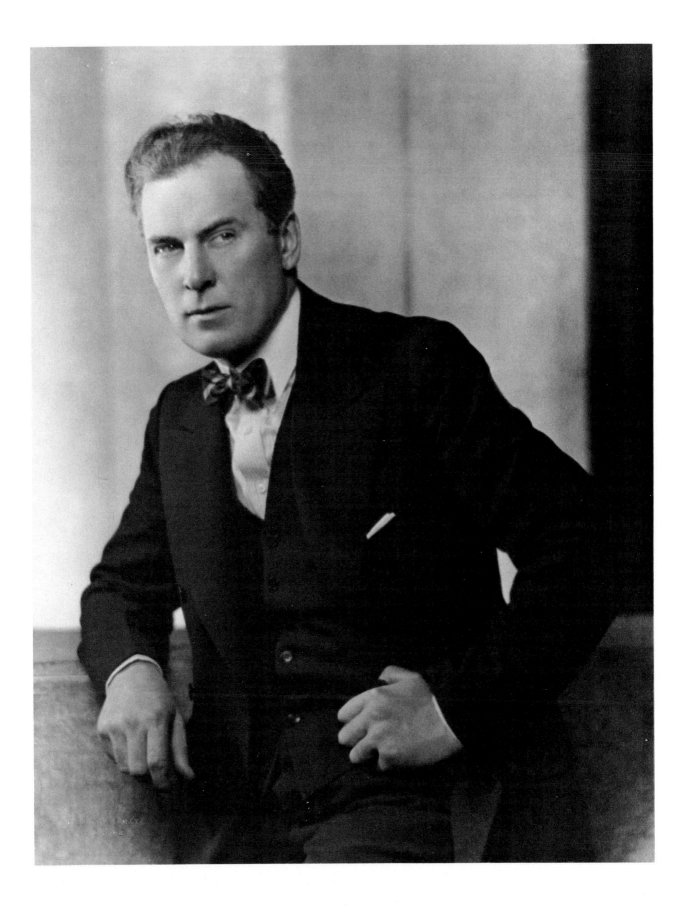

91 Thomas Meighan (1879–1936), actor.

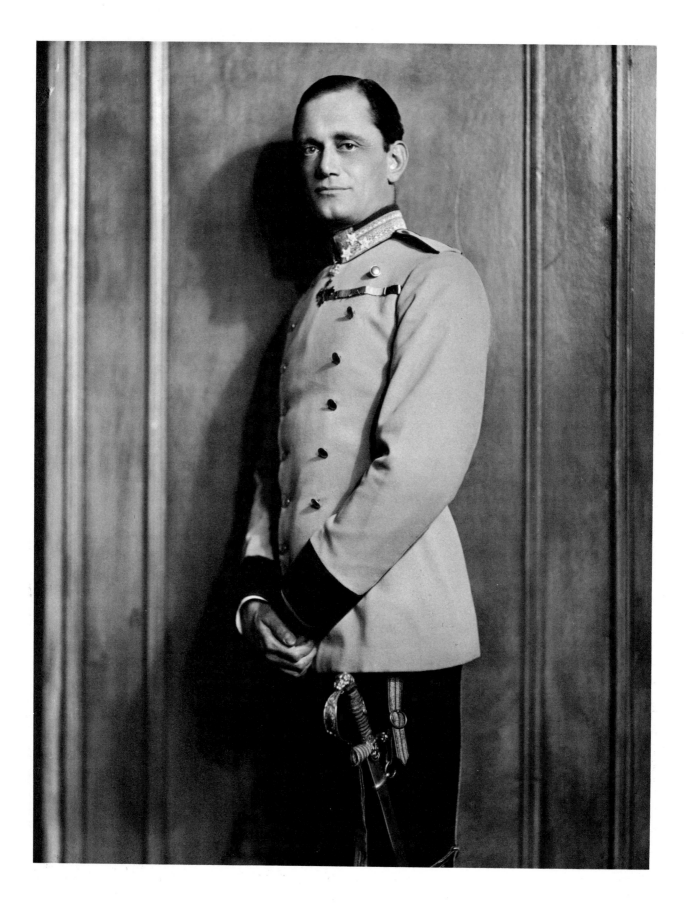

92　Philip Merivale (1880–1946), actor.

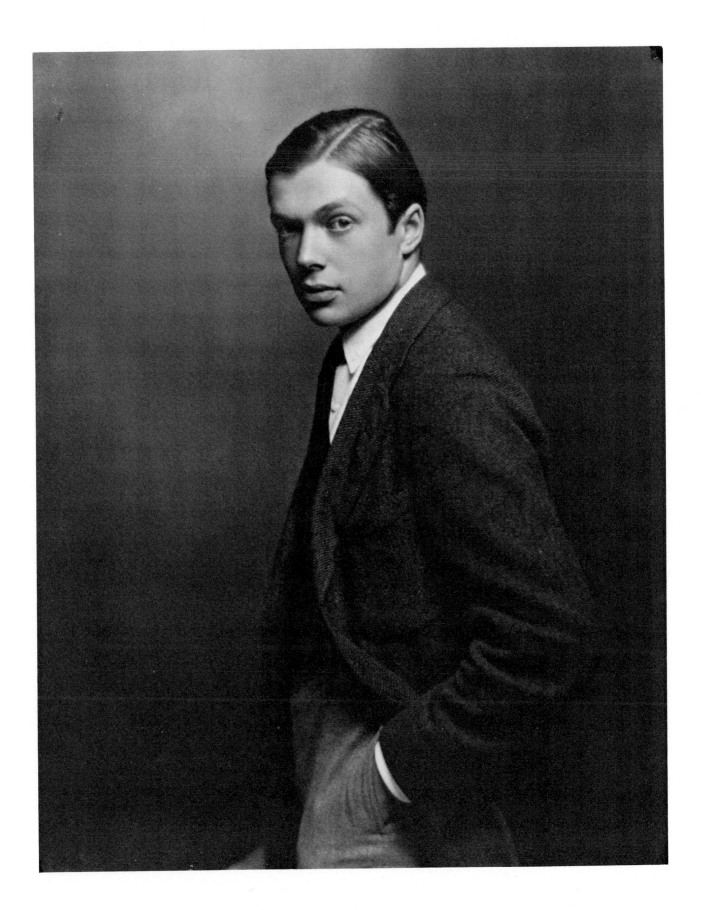

93 Jo Mielziner (1901–1976), theatrical designer.

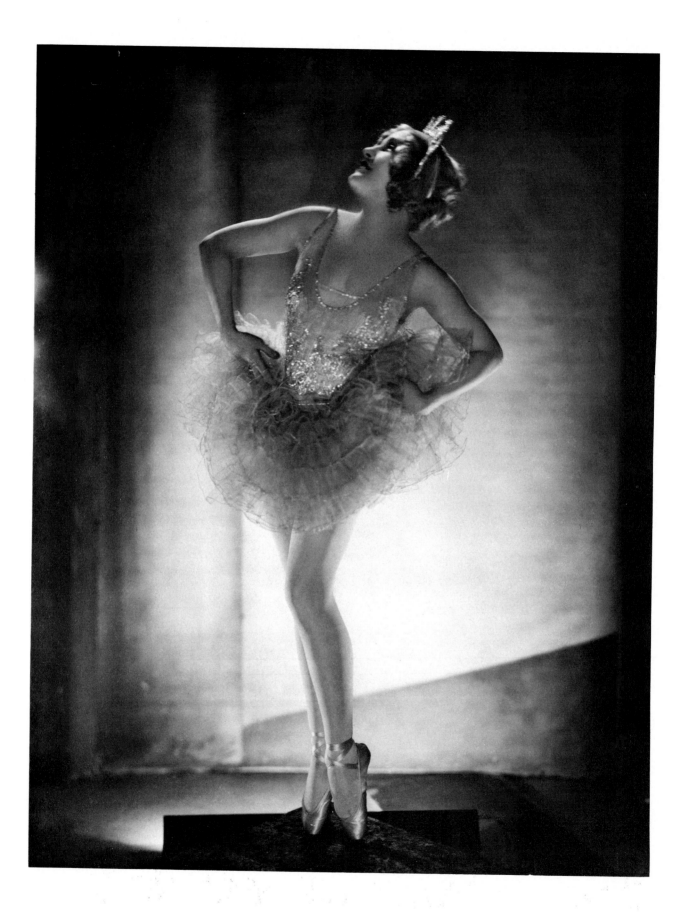

94 Marilyn Miller (1898–1936), popular dancer, actress.

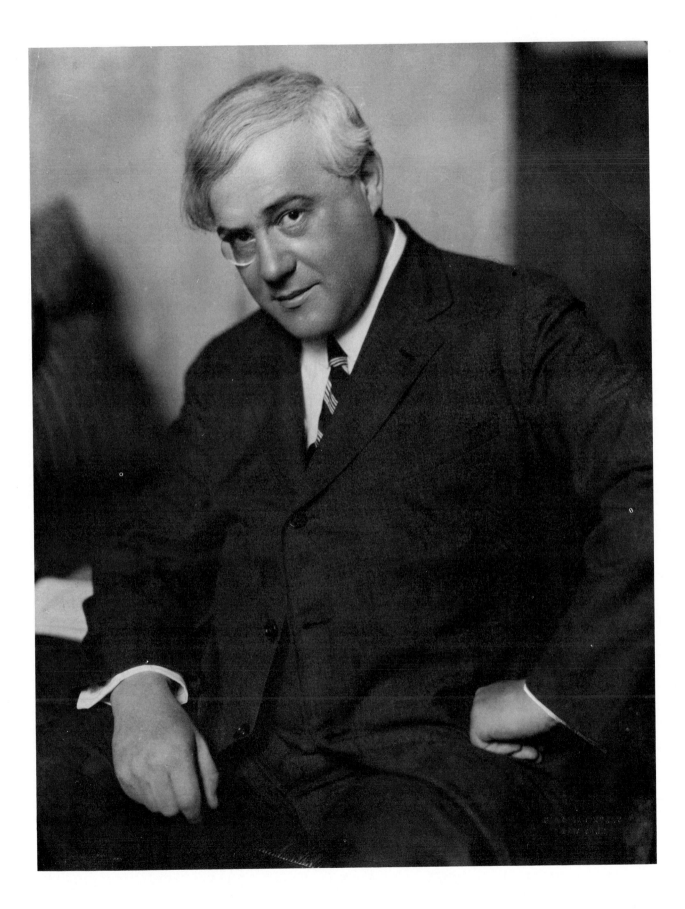

95 Ferenc Molnár (1878–1952), playwright.

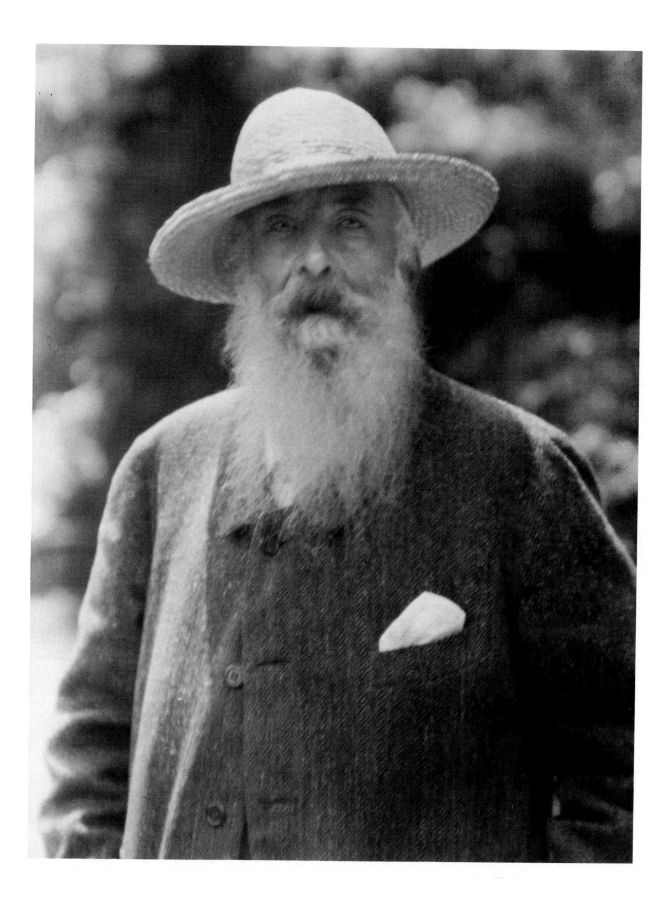

96 Claude Monet (1840–1926), painter.

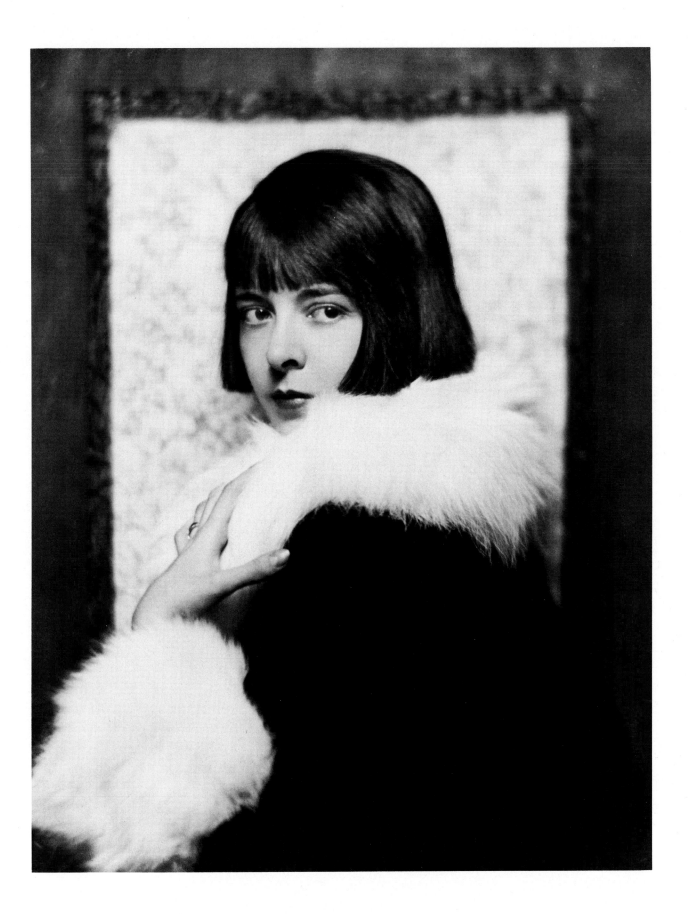

97 Colleen Moore (born 1902), film actress.

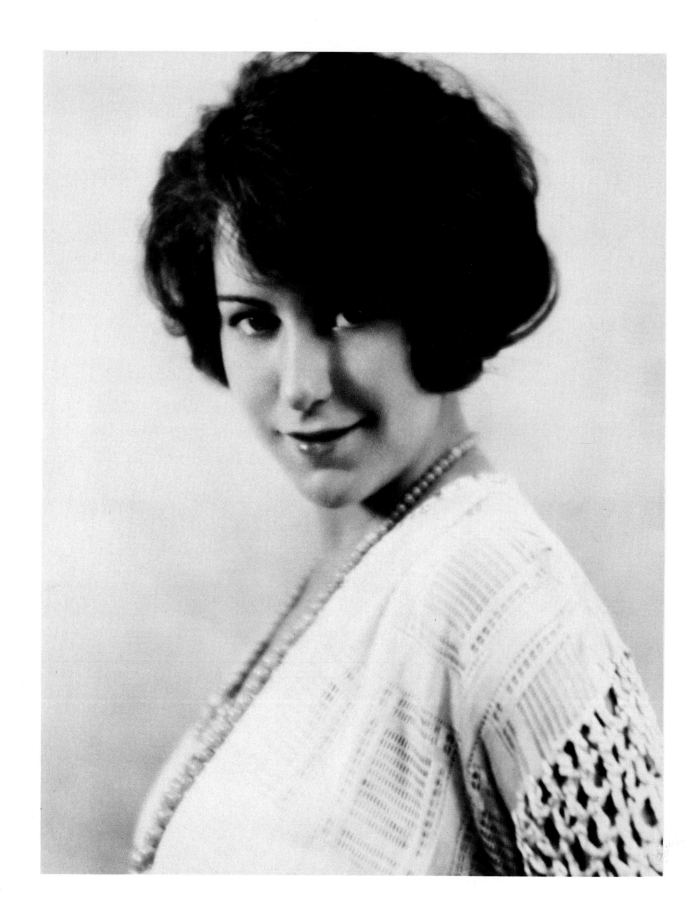

98 Grace Moore (1901–1947), operatic soprano, film actress.

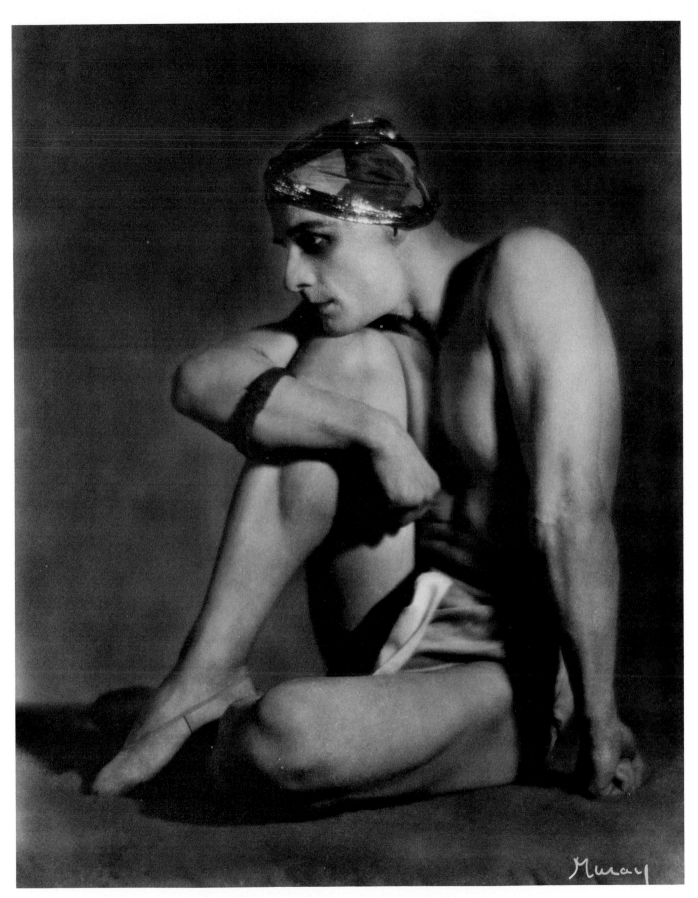

99 Mikhail Mordkin (ca. 1882–1944), ballet dancer.

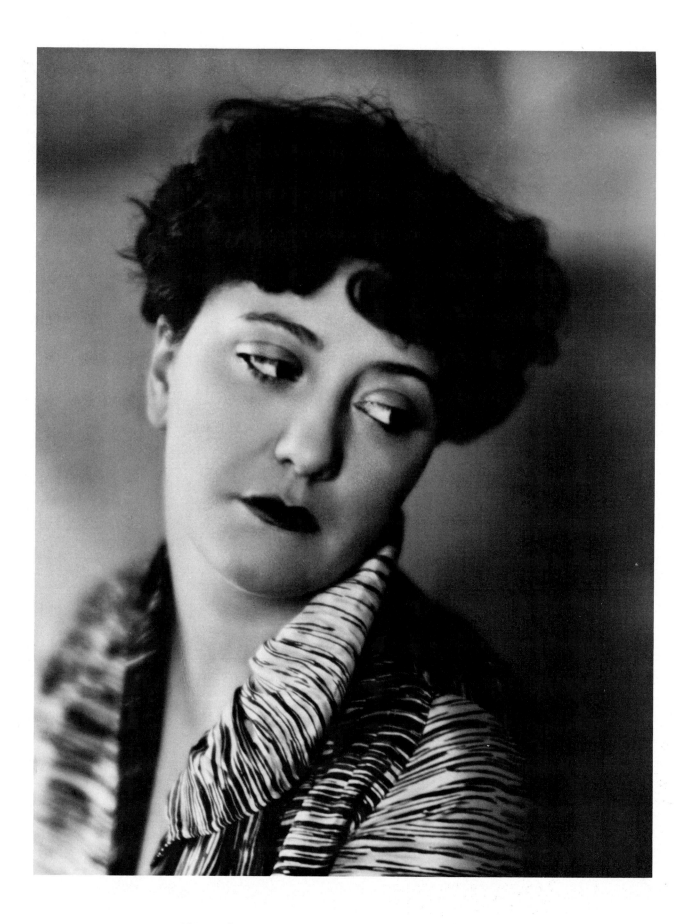

100 Helen Morgan (1900–1941), popular singer, actress.

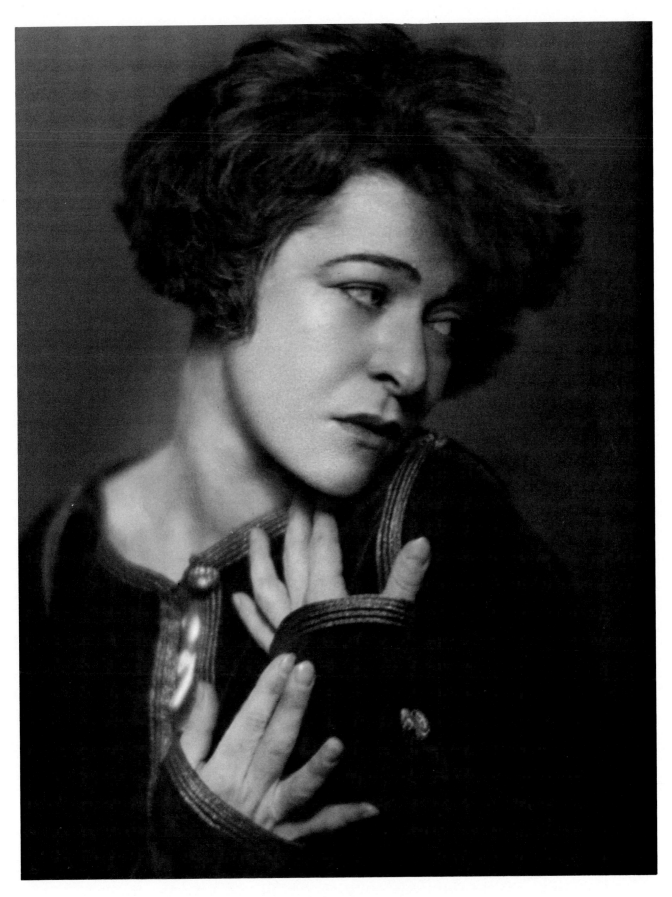

101 Alla Nazimova (1879–1945), actress.

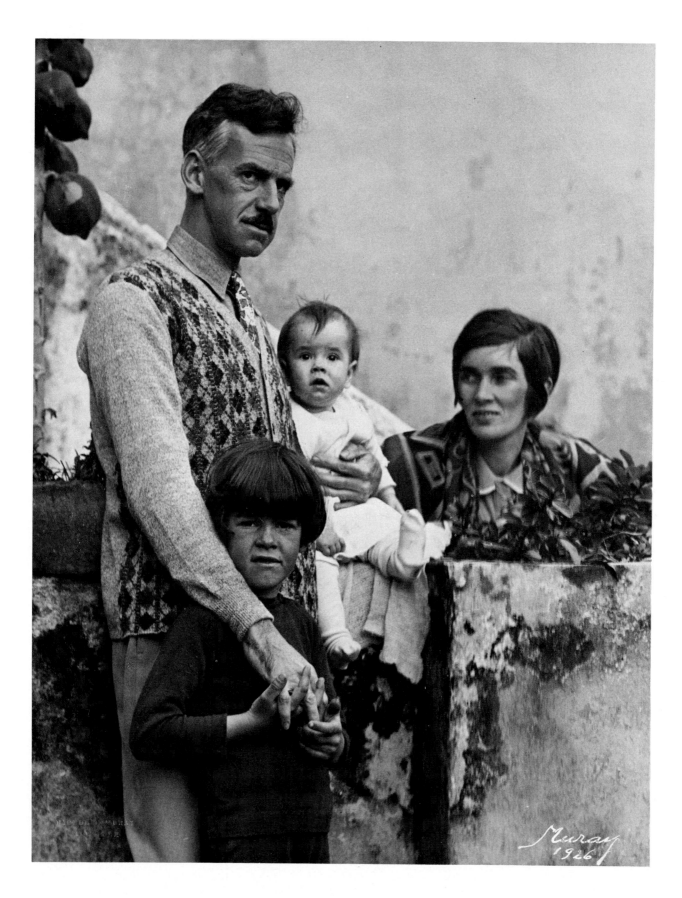

102 Eugene O'Neill (1888–1953), playwright, with his wife Agnes Boulton O'Neill, his son Shane and his daughter Oona, who is now Mrs. Charles Chaplin.

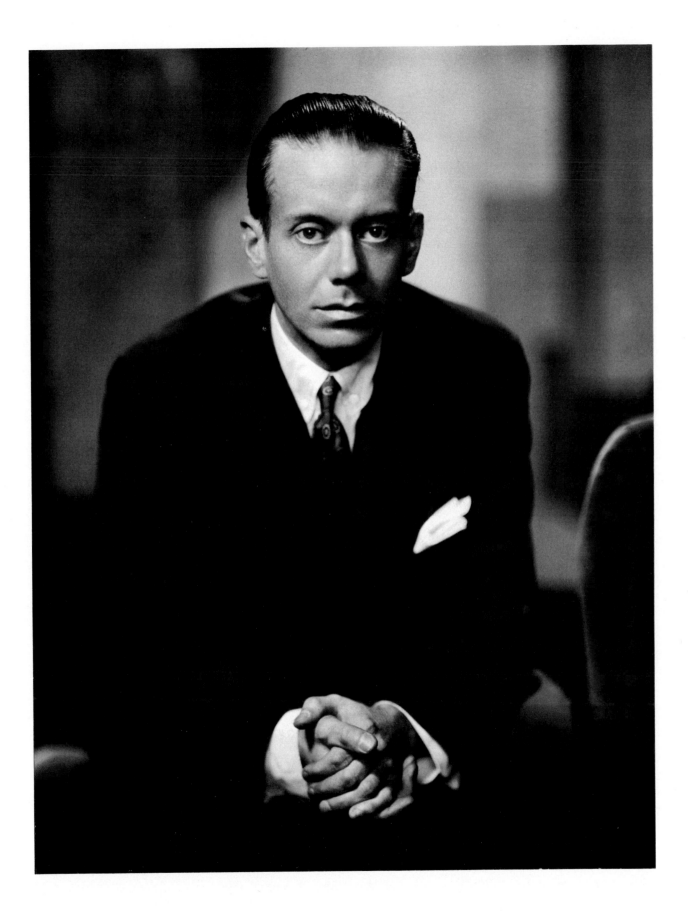

103 Cole Porter (1893–1964), popular songwriter.

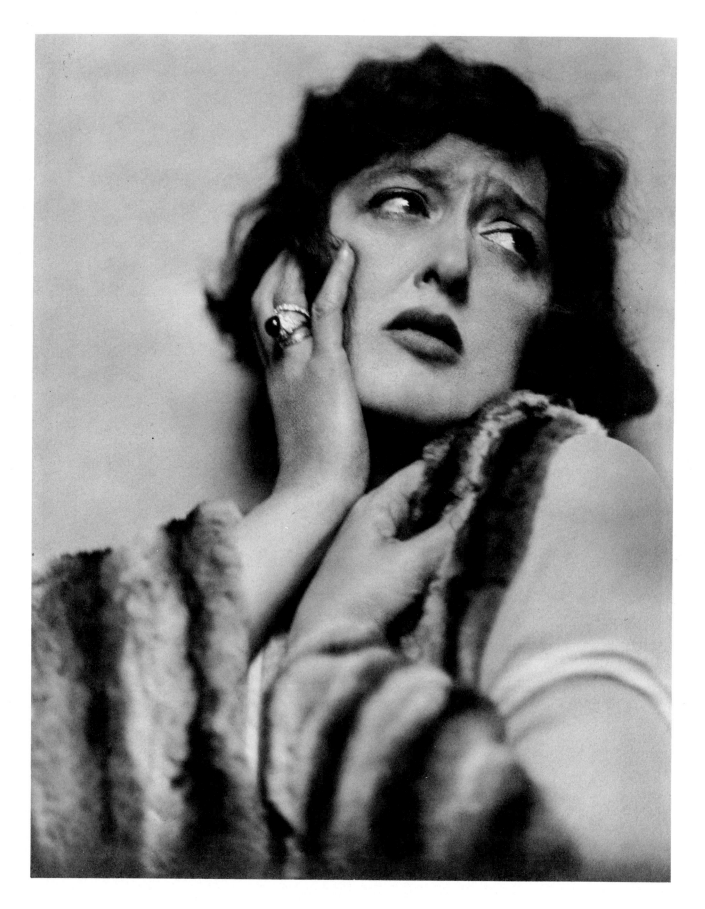

104 Florence Reed (1883–1967), actress.

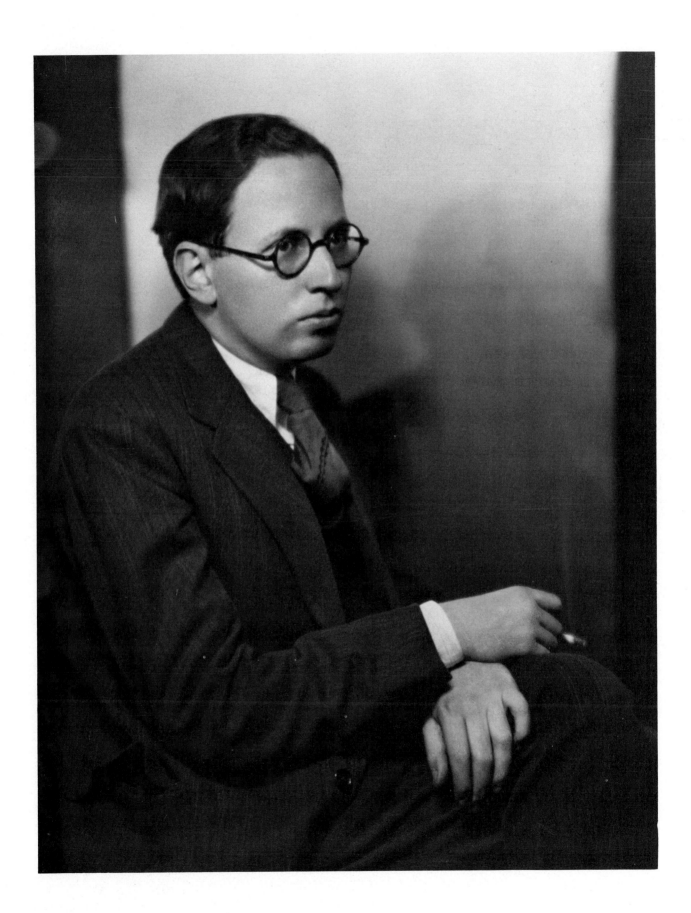

105 Elmer Rice (1892–1967), playwright.

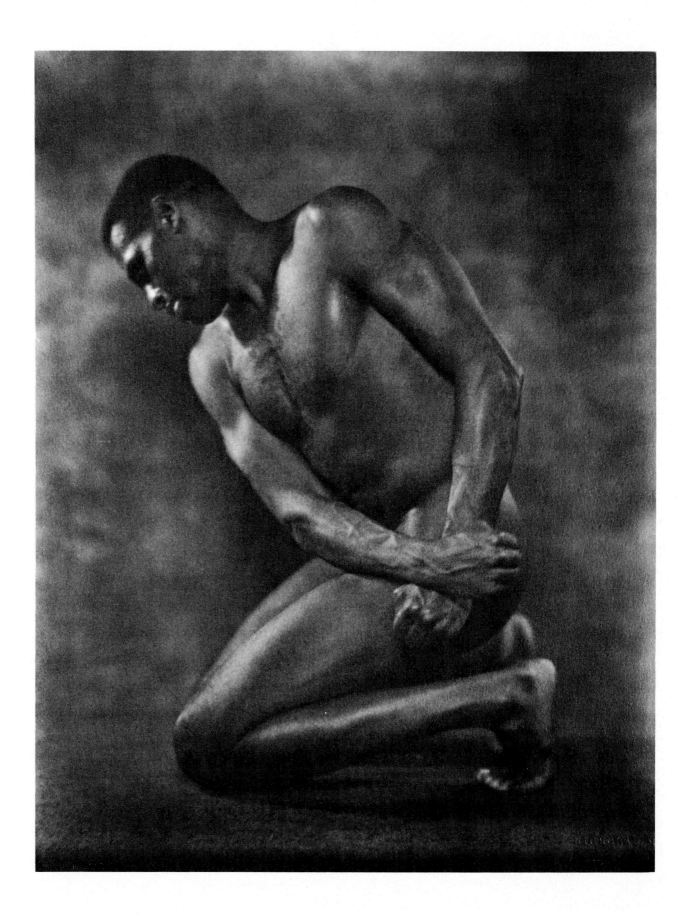

106 Paul Robeson (1898–1976), singer, actor, athlete.

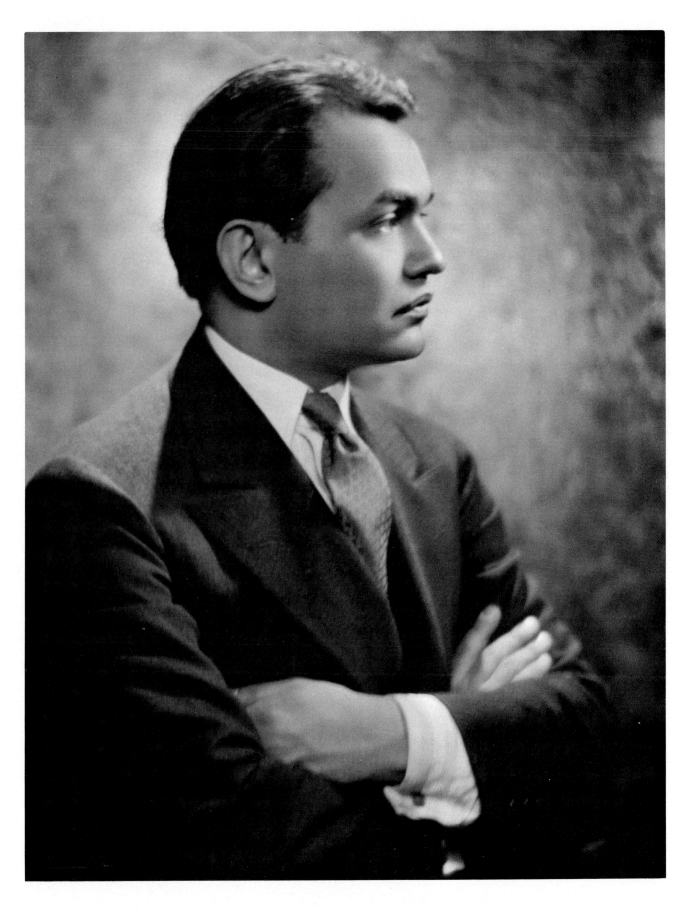

107 Edward G. Robinson (1893–1973), actor.

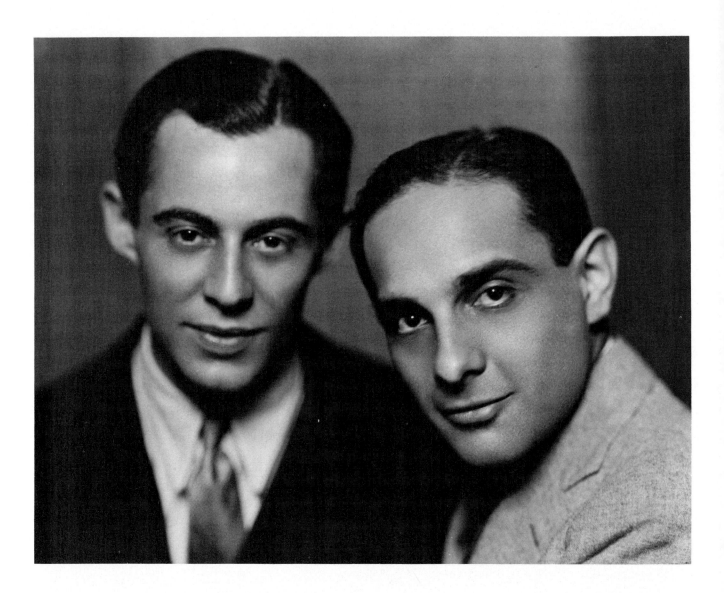

108 LEFT: Richard Rodgers (born 1902), composer.
RIGHT: Lorenz Hart (1895–1943), lyricist.

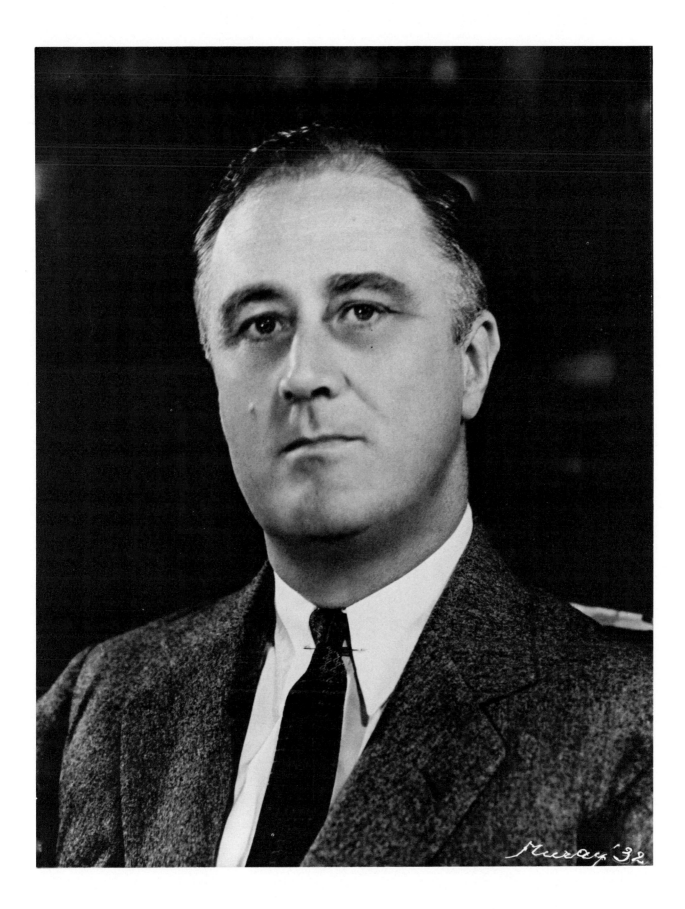

109 Franklin Delano Roosevelt (1882–1945), President of the United States.

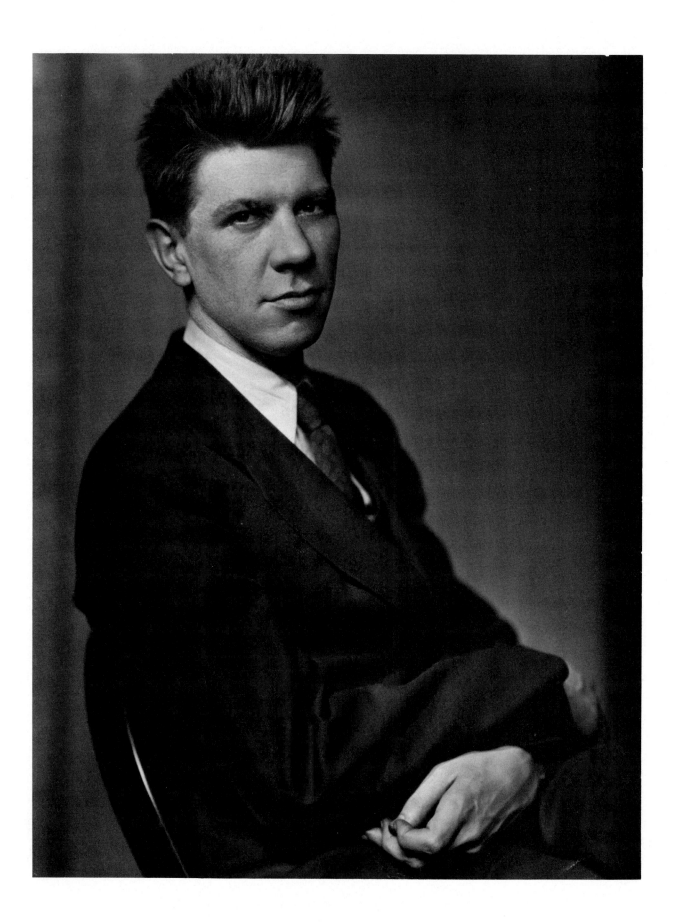

110 Harold Ross (1892–1951), magazine editor.

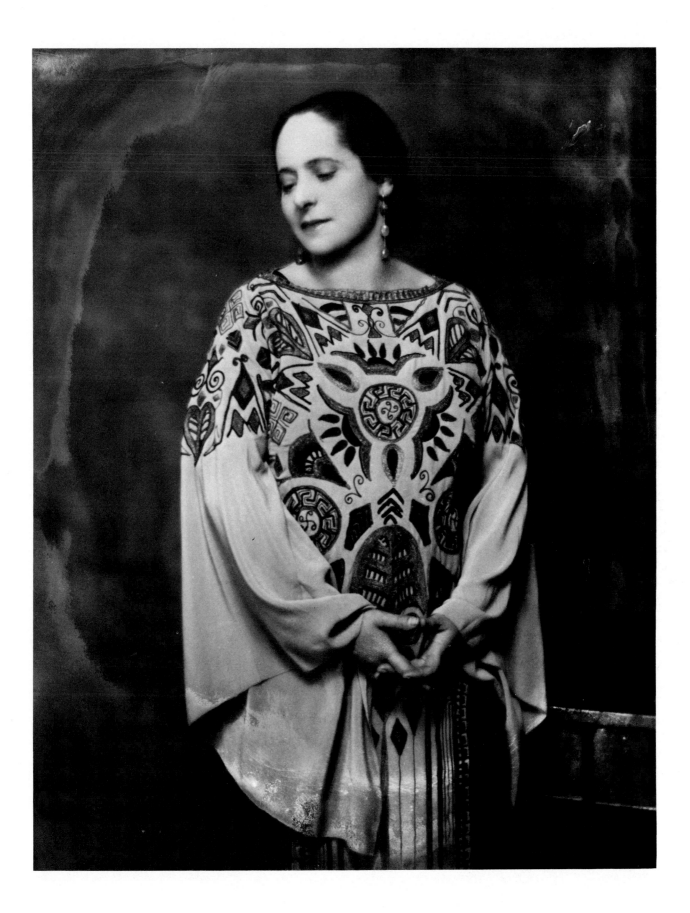

111 Helena Rubinstein (1871–1965), cosmetologist.

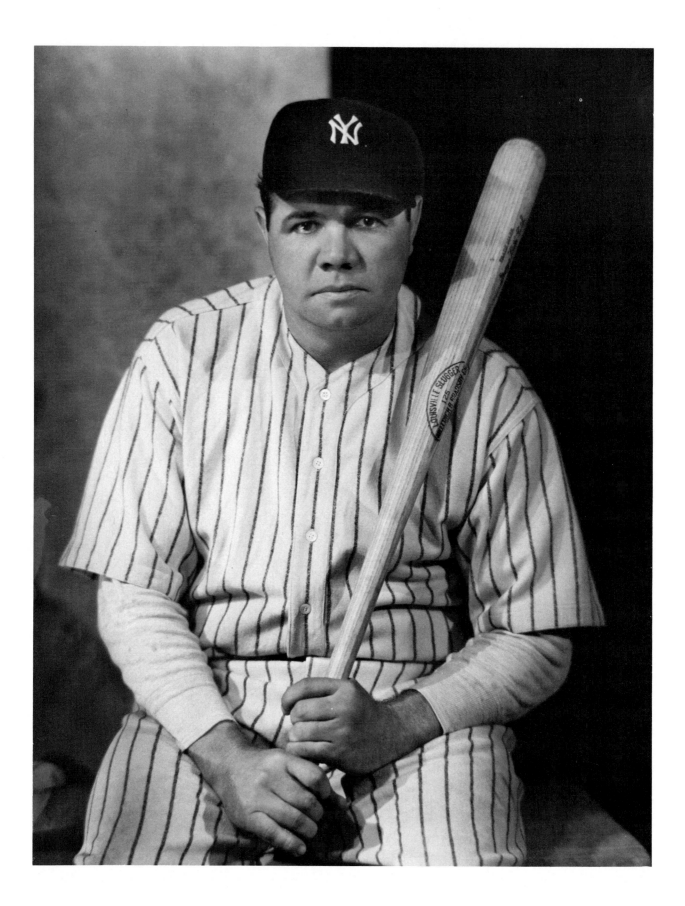

112 Babe Ruth (George Herman Ruth, 1894–1948), baseball player.

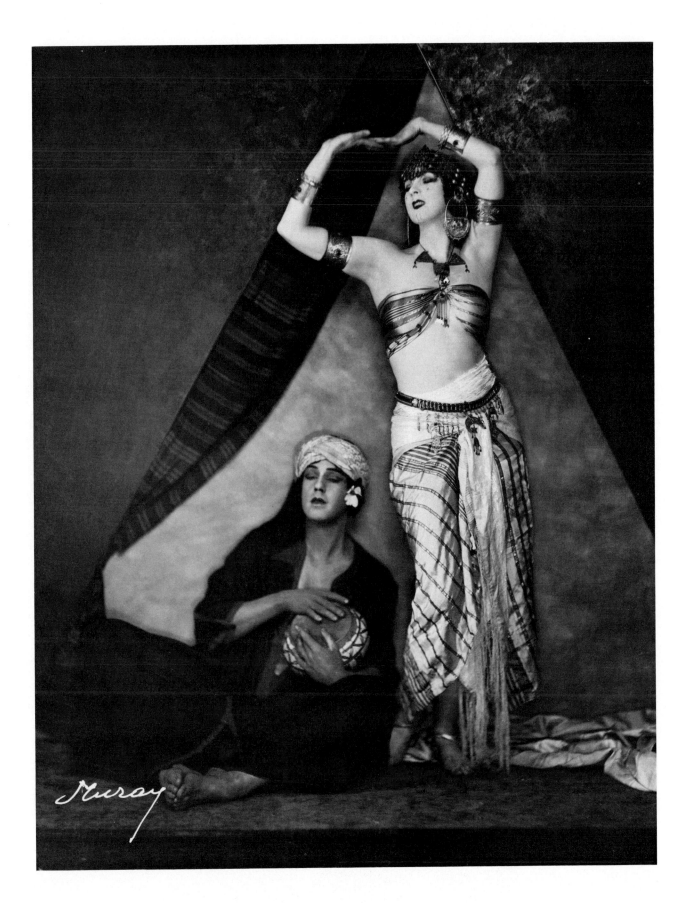

113　Ruth St. Denis (1879–1968) and Ted Shawn (Edwin M. Shawn, 1891–1972), dancers and choreographers.

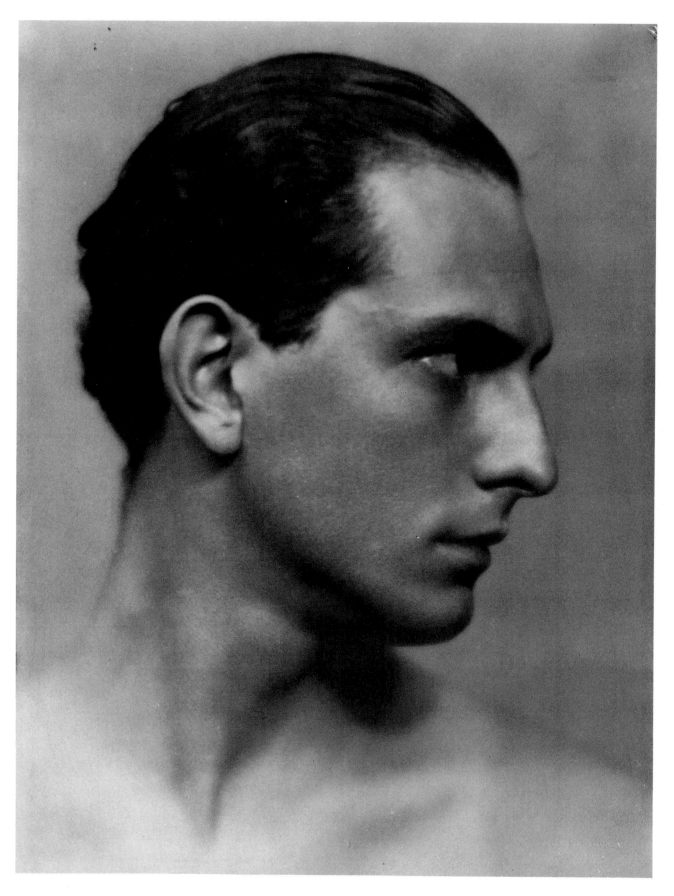

114 Joseph Schildkraut (1896–1964), actor.

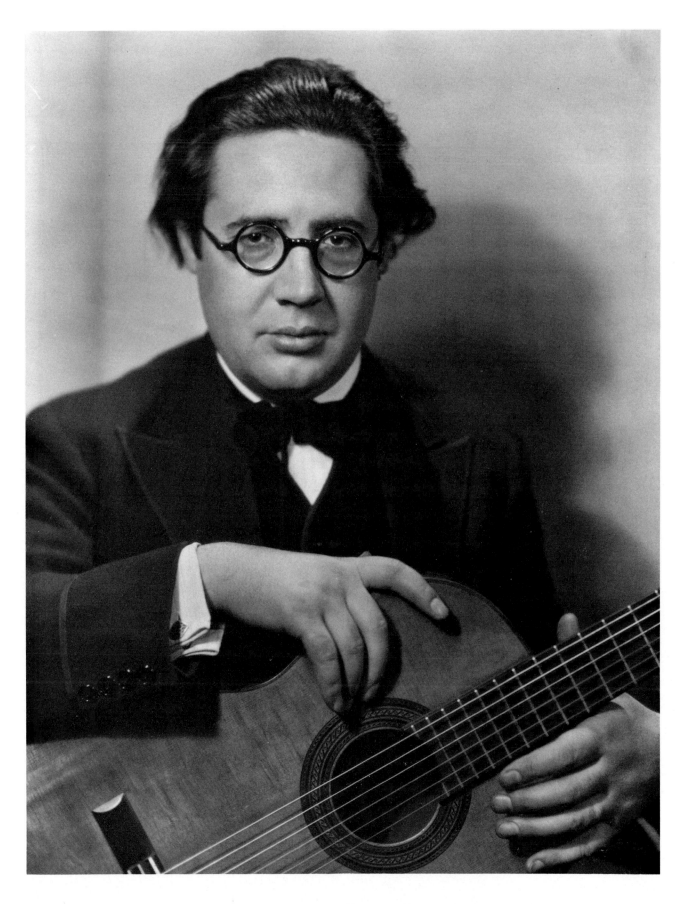

115 Andrés Segovia (born 1894), guitarist.

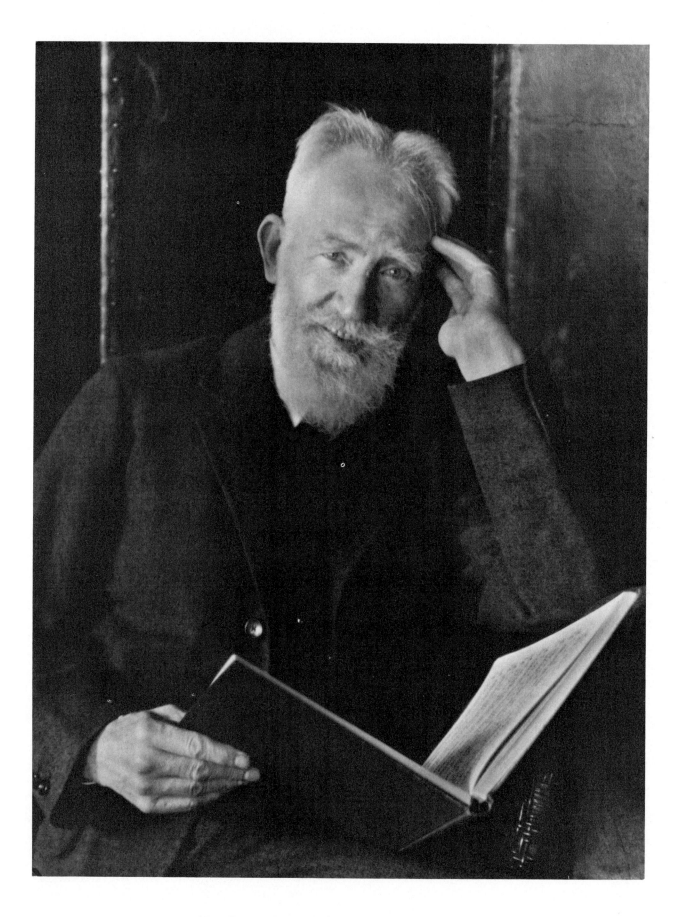

116 George Bernard Shaw (1856–1950), author.

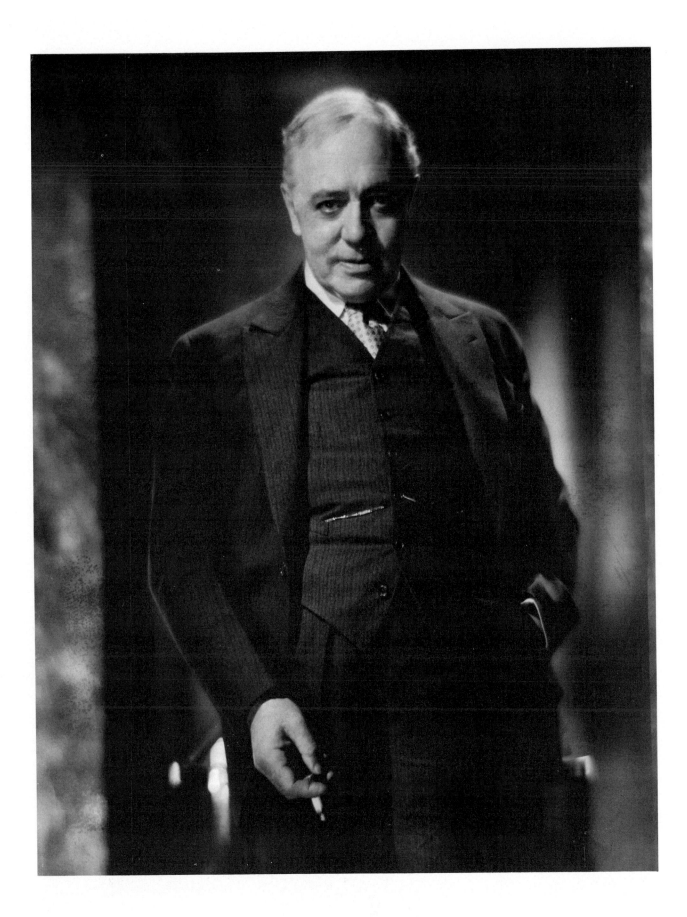

117 Otis Skinner (1857–1942), actor.

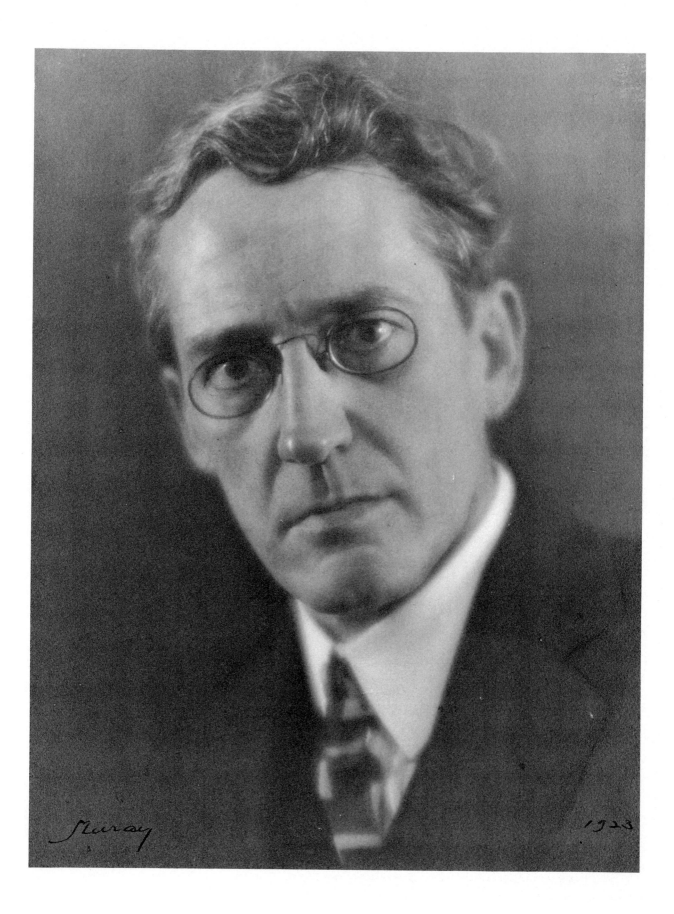

118 John Sloan (1871–1951), painter.

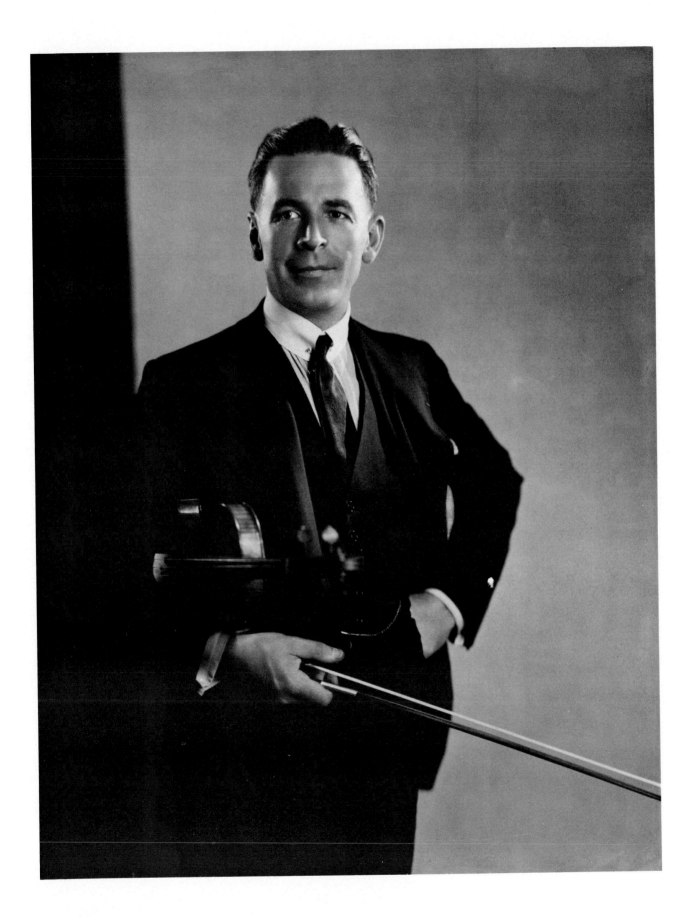

119 Albert Spalding (1888–1953), violinist.

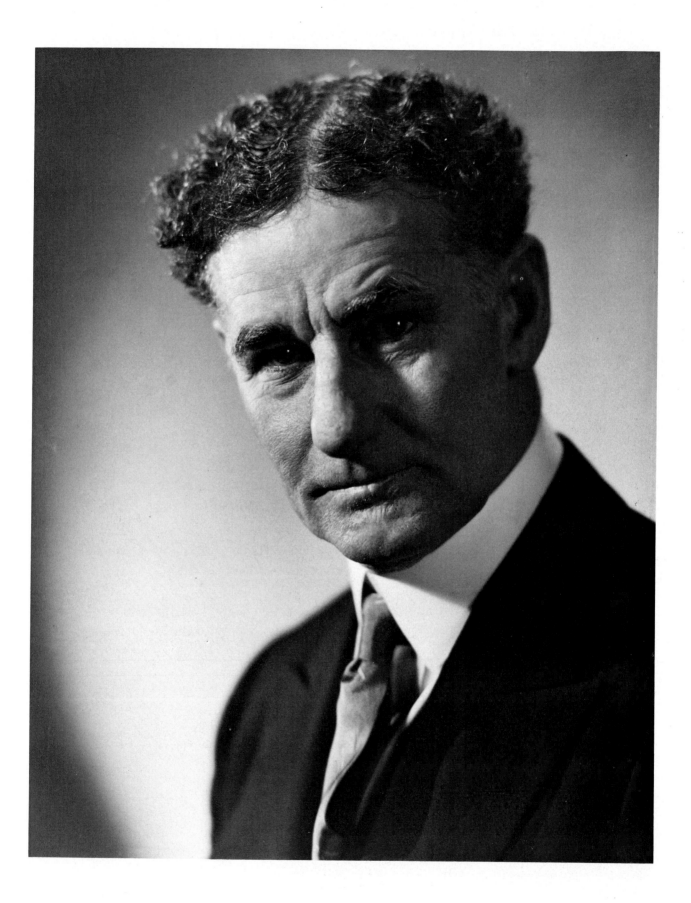

120 Fred Stone (1873–1959), actor.

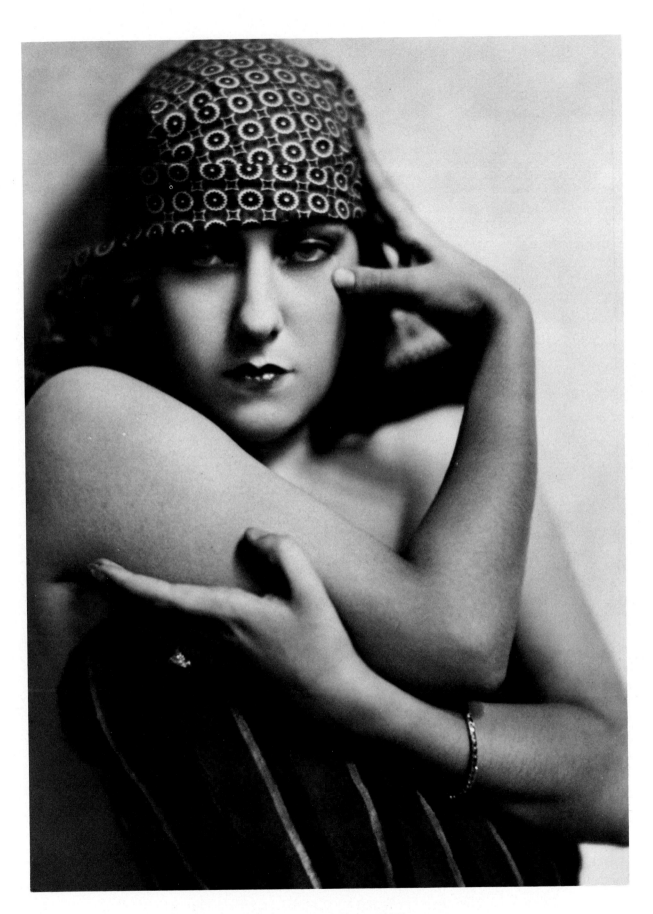

121　Gloria Swanson (born 1899), actress.

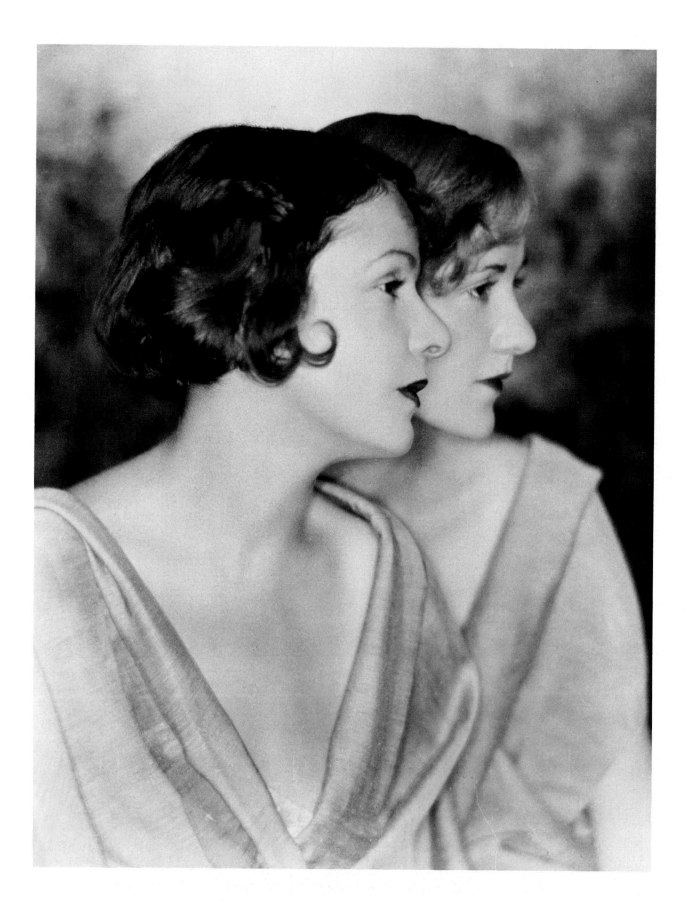

122 Norma Talmadge (1897–1957) and Constance Talmadge (1900–1973), film actresses.

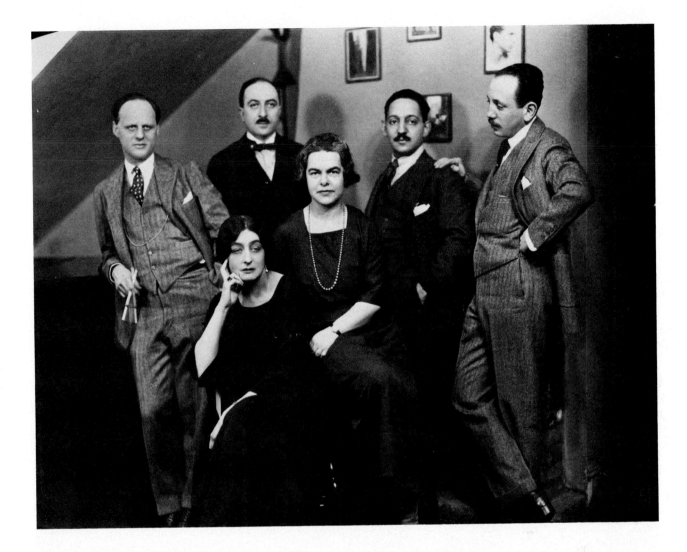

123 The Theatre Guild Board of Managers. SEATED: Helen Westley (1879–1942)
and Theresa Helburn (1887–1959). STANDING, LEFT TO RIGHT: Philip Moeller
(1880–1958), Lawrence Langner (1890–1962), Lee Simonson (1888–1967)
and Maurice Wertheim (1886–1950).

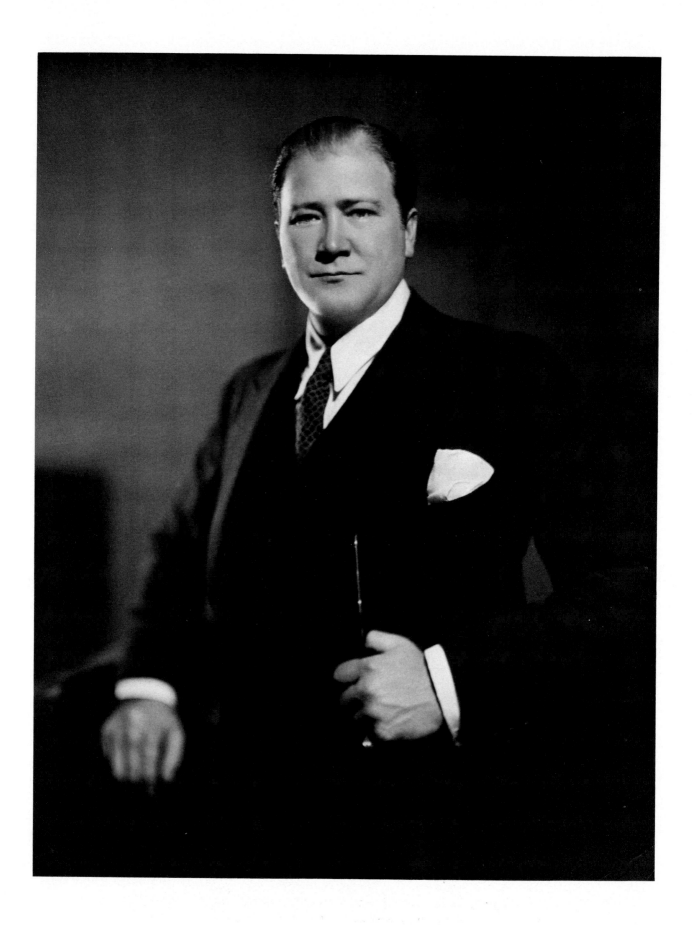

124 John Charles Thomas (1891–1960), operatic baritone.

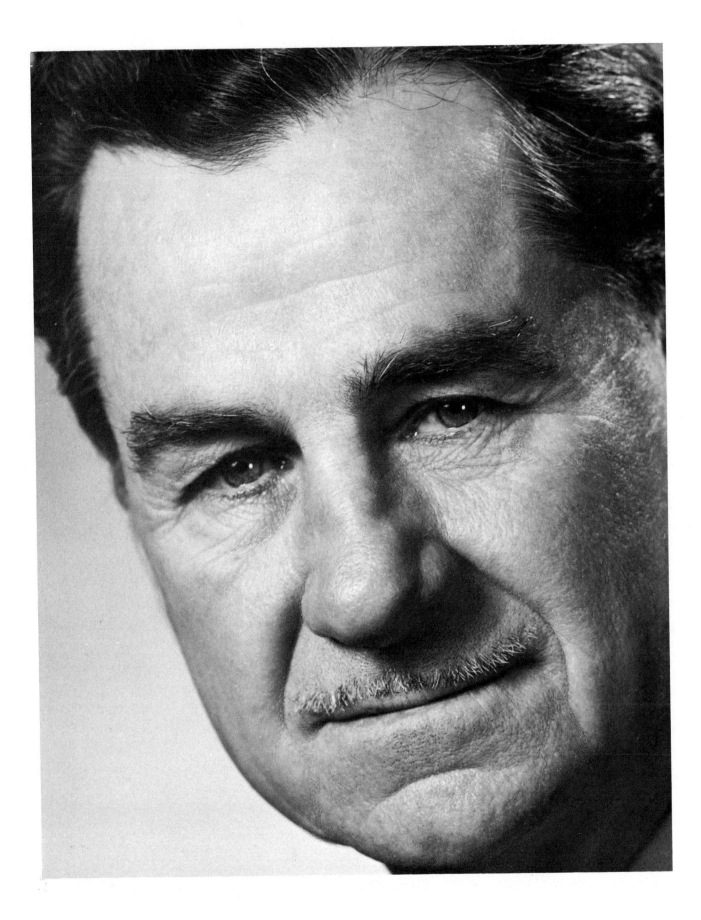

125 Lowell Thomas (born 1892), author, radio and TV commentator.

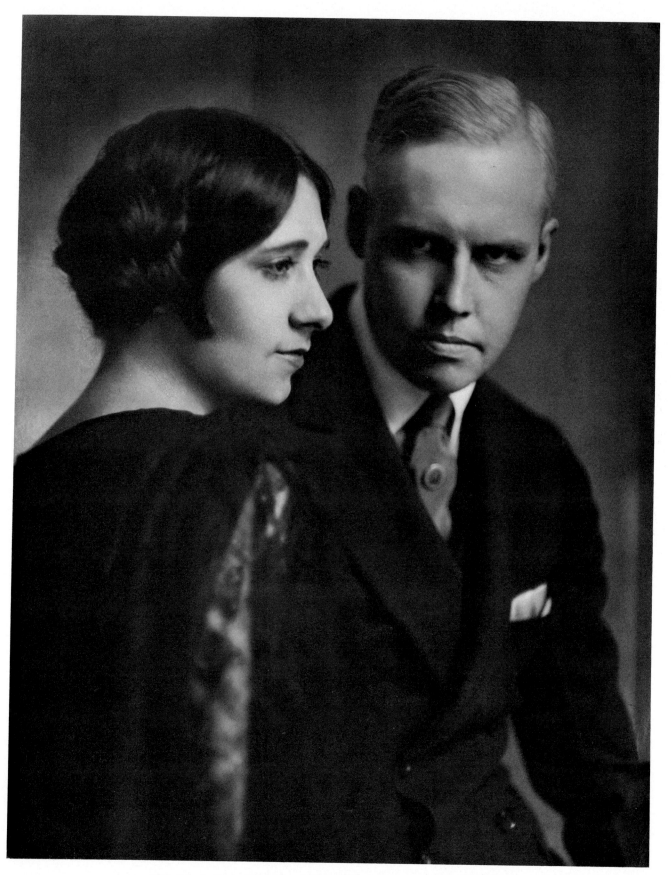

126 Carl Van Vechten (1880–1964), author, and his wife
Fania Marinoff (1890–1971), actress.

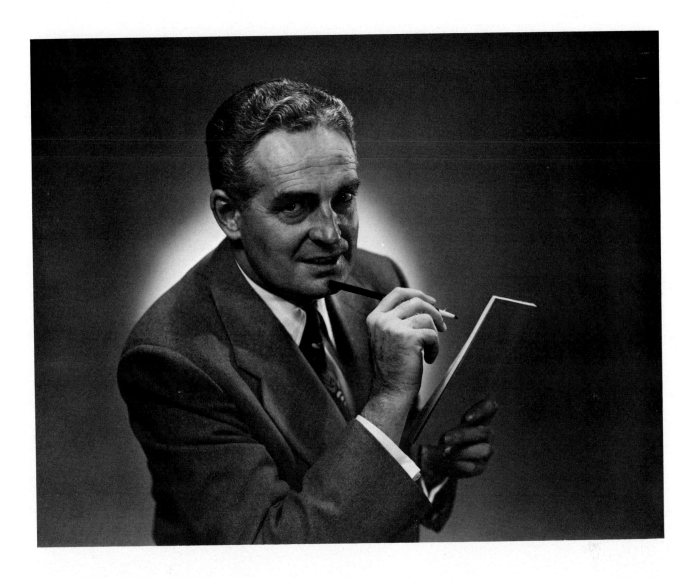

127 Fred Waring (born 1900), band and chorus leader.

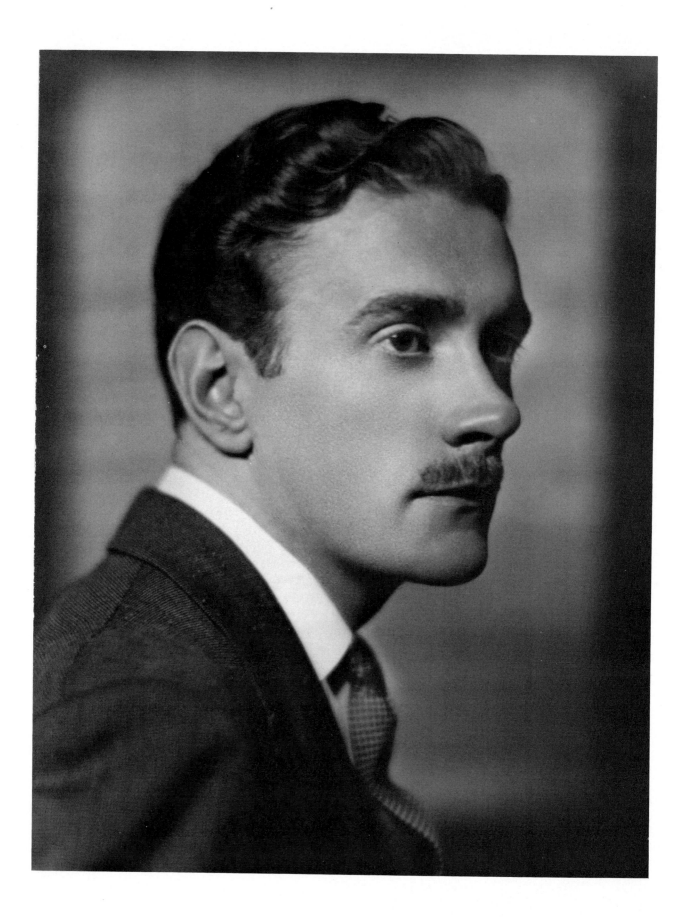

128 Clifton Webb (1889–1966), actor, dancer.

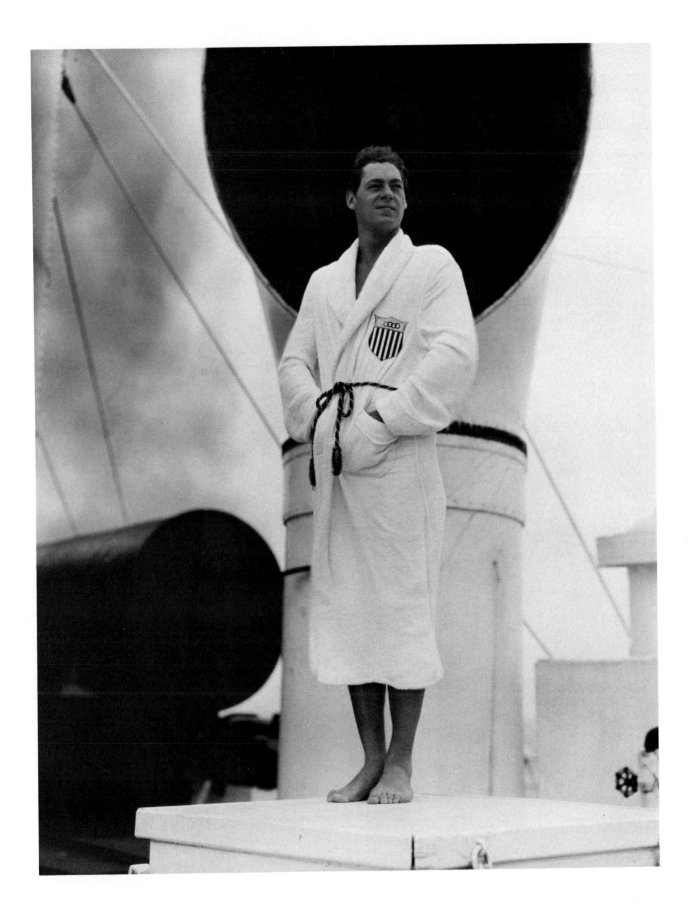

129 Johnny Weissmuller (born 1904), swimming champion, film actor.

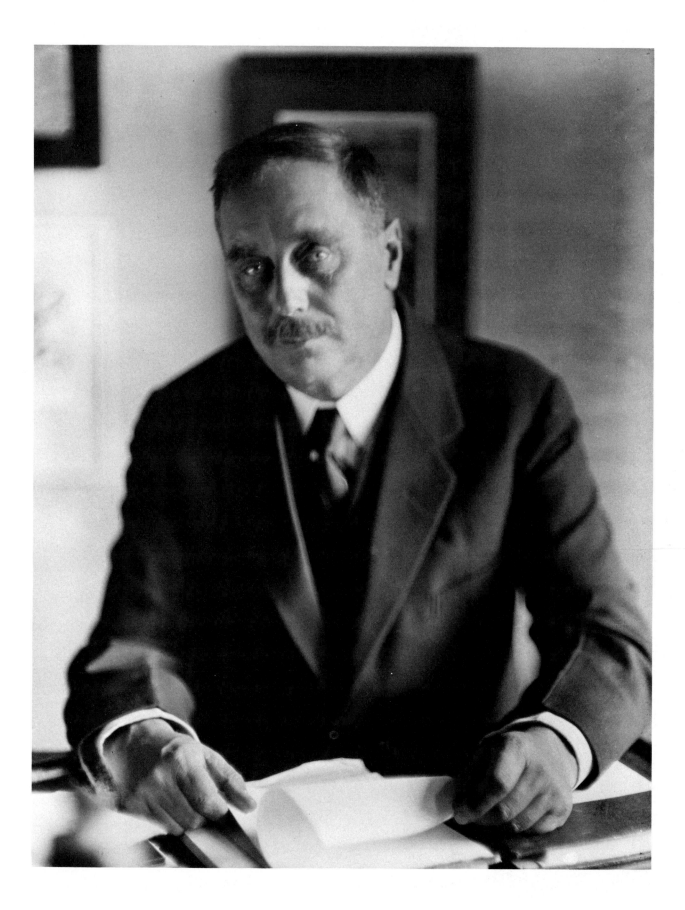

130 H. G. Wells (1866–1946), novelist.

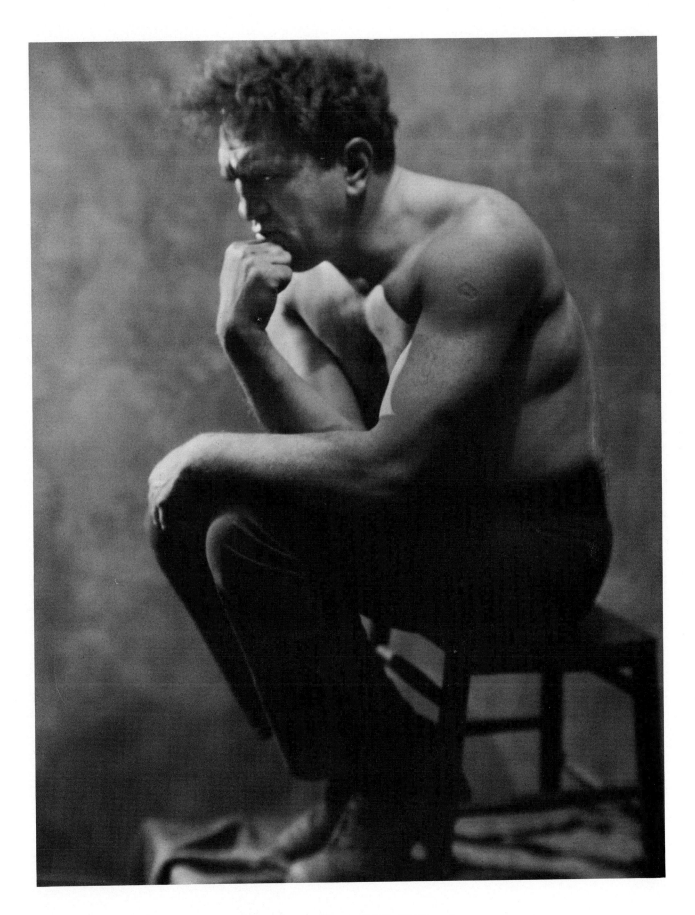

131 Louis Wolheim (1880–1931), actor.

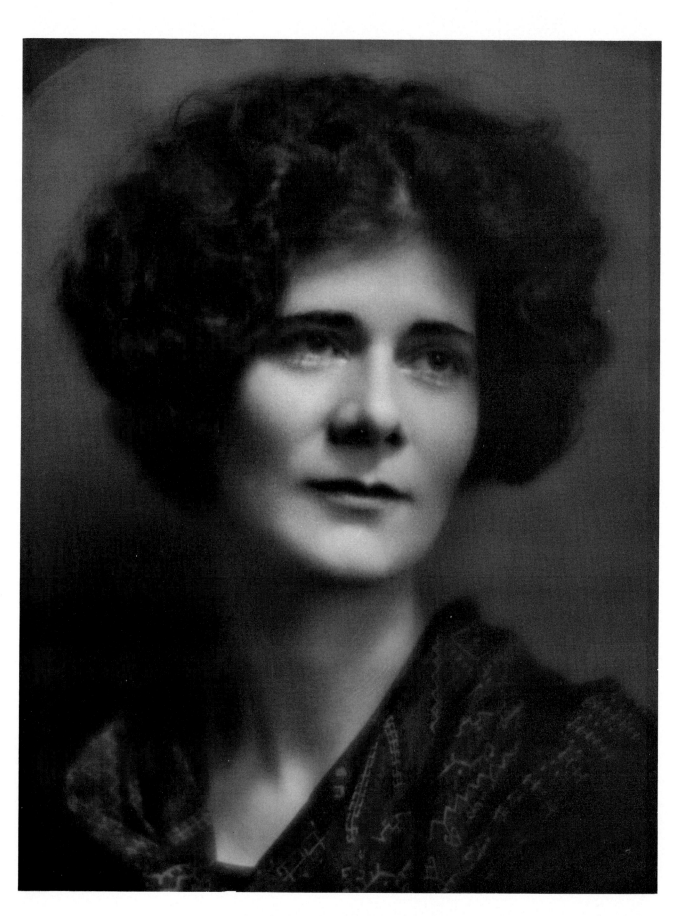

132 Elinor Wylie (1885–1928), poet.

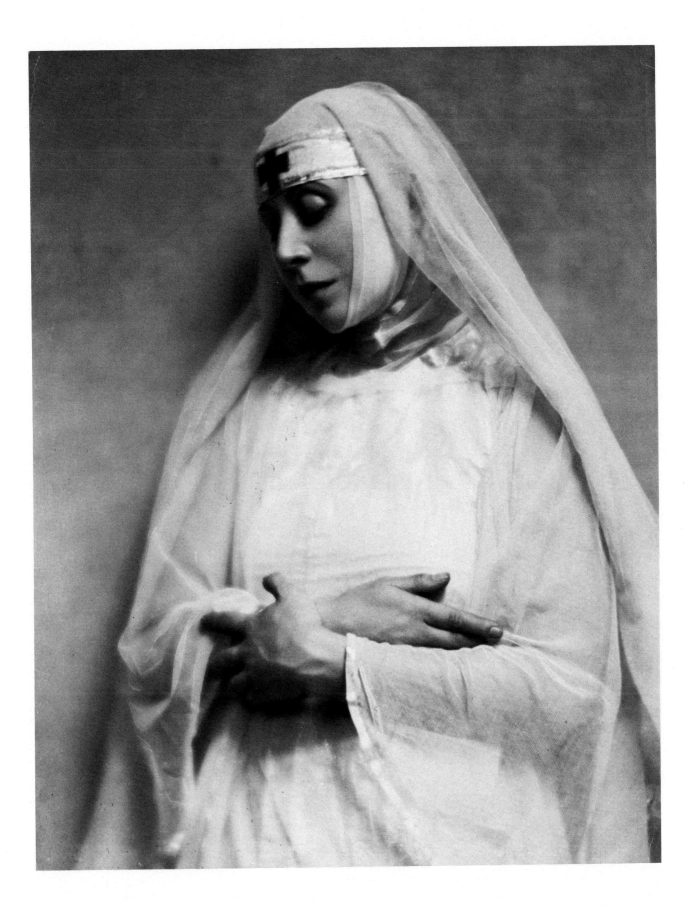

133 Blanche Yurka (1887–1974), actress.

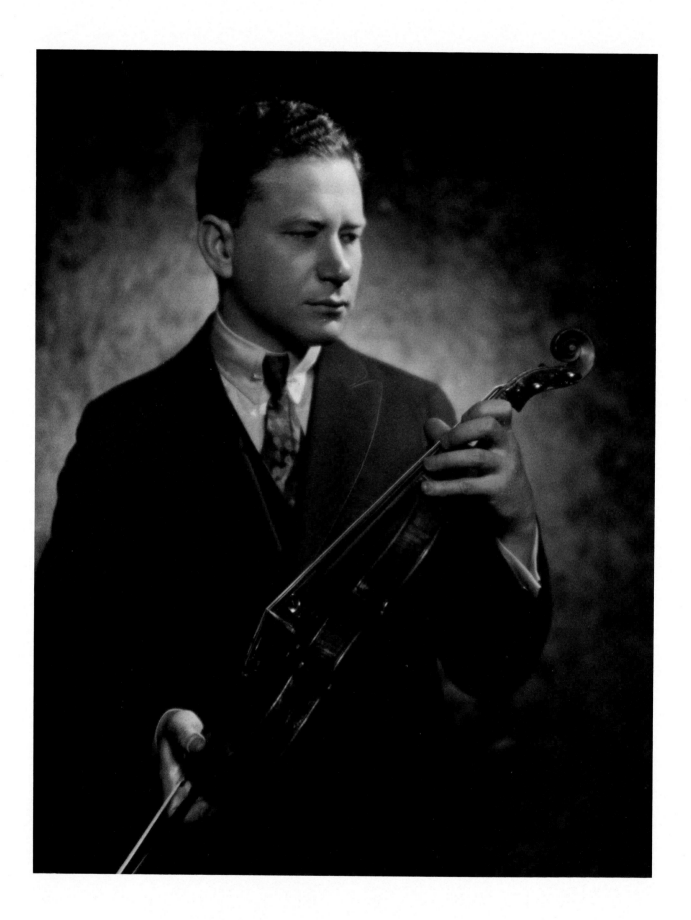

134 Efrem Zimbalist (born 1889), violinist.